Drawing and Painting
Fantasy Beasts

Drawing and Painting Fantasy Beasts

Bring to life the creatures and monsters of other realms

Kevin Walker

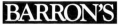

A QUARTO BOOK

First edition for North America published in 2005
by Barron's Educational Series, Inc.

Copyright © 2005 Quarto Inc.

All inquiries should be addressed to:
Barron's Educational Series, Inc.
250 Wireless Boulevard
Hauppauge, NY 11788
http://www.barronseduc.com

ISBN-13: 978-0-7641-3090-0
ISBN-10: 0-7641-3090-0
Library of Congress Catalog Card Number 2004109859

QUAR.FMM

Conceived, designed, and produced by
Quarto Publishing plc
The Old Brewery
6 Blundell Street
London N7 9BH

PROJECT EDITOR: Paula McMahon
ART EDITOR: Stephen Minns
COPY EDITOR: Hazel Harrison
DESIGNER: Paul Griffin
PHOTOGRAPHER: Martin Norris
ASSISTANT ART DIRECTOR: Penny Cobb
PROOFREADER: Sue Viccars
INDEXER: Pamela Ellis

ART DIRECTOR: Moira Clinch
PUBLISHER: Paul Carslake

Manufactured by Provision Pte Ltd Singapore
Printed by Star Standard Industries Pte, Singapore

9 8 7 6 5 4 3 2 1

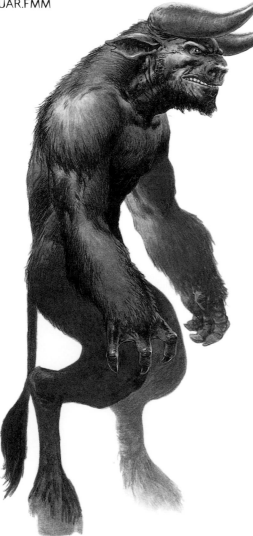

Contents

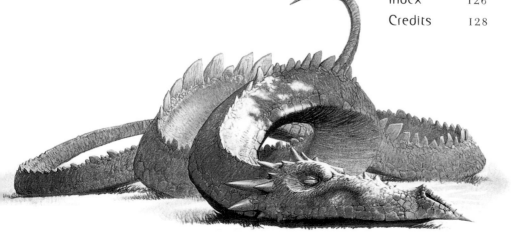

Introduction

Modern fantasy art and literature are steeped in the folklore, myths, and legends of times past, which have always been populated by strange creatures far removed from the domestic animals that share our lives. Fantastic creatures such as dragons, werewolves, and vampires give us enemies to fear and hazards to overcome, while sea monsters provide a visual metaphor for the things we suspect lurk below the ocean waves.

But how do we draw and paint these mythical creatures that we can only glimpse in our imagination? Drawing and Painting Fantasy Beasts answers this question by showing how fantasy artists produce their visions of strange worlds and the beasts that dwell in them. Most fantasy has a starting point in reality, so look at real animals, birds, and insects and try to envisage ways of turning them into something different by distorting anatomical forms or altering scale. A cockroach is nasty enough on a small scale, but think of one as big as a house!

The book begins by suggesting where you might find ideas and inspiration for your work, and then shows you some useful techniques for a number of different drawing and painting media. The Bestiary, organized

into six different habitats, offers ideas for inspiration and several beasts to draw and paint. Each entry features a finished illustration of the creature and suggestions for recreating it—and that's not all. In a series of special panels you will also learn vital facts about it, such as how much it weighs, what it eats, what it smells of, and where and when to look out for its appearances.

The Bestiary section is packed with exciting ideas, including hints on suggesting movement, suggestions for deciding on poses, and practical lessons on drawing claws, scales, teeth, and other vital attributes of fantasy beasts. A series of "artist at work" demonstrations allows you to look over the artists' shoulders as they take you step by step through the creation of a range of beasts, exploring a range of styles and approaches to help you develop your own way of working.

So get cracking! Follow what the artists have done or use the demonstrations and illustrations as a springboard for taking off into your own realm of fantasy and imagination.

K. Walker

Getting Started

This section of the book will help you get started in the world of fantasy art. It offers advice on your workspace, help with your choice of media and tools, and a description of many techniques that are designed to help you produce the desired effect as simply and quickly as possible.

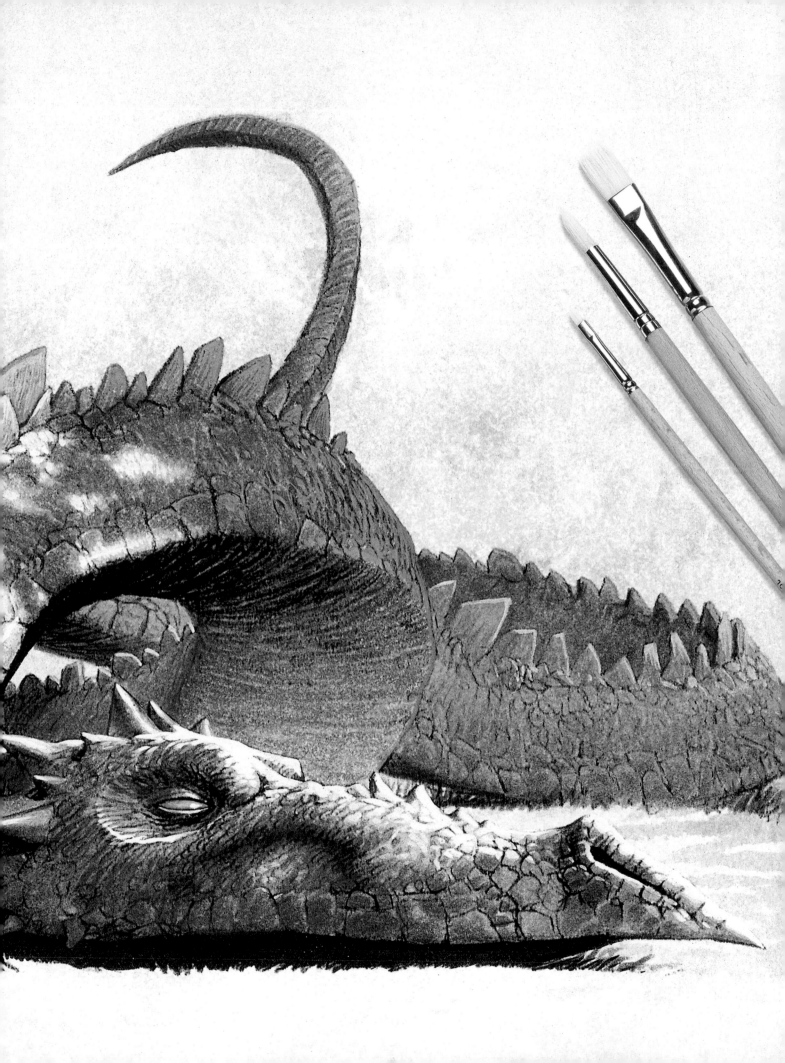

Where do the ideas come from? This is a question most artists are asked from time to time, especially if their specialty is fantasy art, and the only real answer is "everywhere and nowhere." Ideas can't be summoned up to order, and often come to you when you least expect them, sometimes triggered by random visual effects such as a pattern of light on a wall. As children we have all seen faces or strange creatures in a fire or in cloud formations, but in a busy world we sometimes lose the ability to give free rein to our imagination. So keep your mind open, and don't rule anything out.

Starting points

Truly original ideas are very rare; they are the province of a few visionary artists whose inspiration comes from somewhere deep within themselves. Most fantasy art has a starting point in reality, and this is especially true of fantasy beasts—you can't create a real-looking creature without considering those that actually are real. Your beasts must look as though they can move, eat, hunt, and do all the things that living creatures do, however strange their structure, habits, and environment. So try to understand how a skeleton and layers of muscle can form the outward shape of a creature and how movement affects this shape. Zoos could be a useful place for gathering ideas, but if you don't have access to one, look at videos, illustrated books, and photographs of animals and insects to discover how they are constructed—you will often find that fact really is stranger than fiction.

Wonders of nature
Some of the world's real animals are truly fantastical. The color of this red fish is out of this world.

Past and present

It's always worth looking at the work of other artists, too. Fantasy beasts have featured in art throughout history, from prehistoric cave paintings through the gargoyles of medieval times to the graphic novels and computer games of today. If you have a particular type of creature in mind, look at how other artists have approached the concept through the ages. Don't waste time wondering how they have made the drawing, painting, or sculpture; what matters is the shapes created and the reasoning behind the creation.

Myth and folklore are also good sources of inspiration, and here you have a wide choice of material—all cultures have their own ideas of strange creatures, often with magical abilities. Written accounts may often be more valuable than visual renderings because they leave more to the imagination and don't tempt you to copy.

The natural world
The earth is capable of amazing feats of destruction and renewal. Who knows what creatures might evolve with it.

BENDING REALITY

Even if your creature is based on a real one, or a combination of several, you can give it a more fantastical appearance by changing the scale or setting it in a different environment. Creatures that are microscopic in real life can become gargantuan in your creation, or something that exists only in the sea can be transposed to another setting, becoming modified along the way. A jellyfish wouldn't last long in a desert, but by taking its basic shape and giving it a rigid skeleton and a different skin surface you can create a whole new creature. And, of course, you can "mix and mismatch," using the eyes of one creature and the ears of another. Imagine a horse with the hair of a dog and the ears and tail of a pig, for example.

KEEP A VISUAL RECORD
A digital camera is great for taking photos of scenery or animals. You can load the pictures directly onto your computer and use them as the basis for your image.

COLLECTING VISUAL INFORMATION

When you have an idea, don't waste it; act immediately to record it. Notebooks and sketchbooks are vital, and a scrapbook is also a good idea because it provides a way of keeping interesting images you may find in magazines or newspapers, as well as scraps of material and anything else that might come in handy for the colors and textures of your creatures. Keeping a camera with you will help you to make visual notes of anything you may see when out and about, and these days this is much easier than it used to be when cameras were heavy and unwieldy. Digital cameras are light and easy to use, and even cameras built into cell phones can be a useful tool for helping you to remember things you don't have time to sketch, although the images they produce are often not good enough for reproduction.

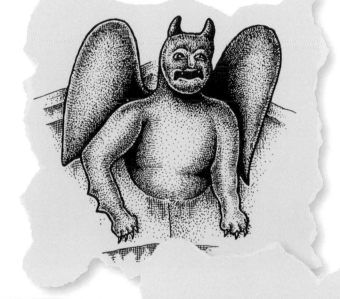

ARCHITECTURE
Gargoyles such as this one can be found adorning buildings all over the world.

HISTORICAL DRAWINGS
People have been drawing fantasy animals for centuries. This griffin is a late medieval engraving.

The type of art you do dictates the type of equipment you need. Commercial artists, unlike fine artists, work to meet other people's needs and deadlines. Their work space and equipment must enable them to do their work as efficiently as possible. It doesn't have to be expensive, but it must be comfortable and appropriate for the job.

THE STUDIO

The first requirement is a place to work. You don't really need a dedicated studio space, but you must feel comfortable and be able to concentrate without unnecessary distractions.

If you have a spare room with good natural light, so much the better, as lighting is vital if you are working in color. Poor light not only is bad for your eyes but it also affects your perception of the colors you are using. You notice this if you complete a painting in standard electric light, which has a yellowish cast, and then look at it again in daylight.

Daylight is always best, but of course the amount of daylight you get is not guaranteed. If you live in the Northern Hemisphere, a large north-facing window is ideal because you will get no direct sunlight and thus little change through the course of the day. But don't worry if you don't have this luxury, because any window is better than none. If you are working in a sunny room and find changes in the light distracting, you could consider putting up a translucent white blind, which will diffuse the light, making it more even. A white sheet would make a less expensive alternative. If possible, position your table so that your hand does not throw a shadow, which can make it difficult to see what you are doing.

BOARDS, TABLES, AND CHAIRS

The working surface you choose depends very much on how large you want to work. Most artists use a drawing board of some kind, whether a ready-made one or a sheet of medium-density fiberboard (MDF) or plywood cut to the required size. Some drawing boards can be angled up from the horizontal, giving a good slope to work at as well as preventing back strain, but if you are using a homemade board you can prop it up on wooden blocks or a pile of books.

You will need a table that gives you enough room for all your

DRAWING BOARD
An angled board is ideal for drawing and it helps with your posture, too.

drawing and painting tools, but again you don't have to buy one unless you are setting up a more permanent workspace. The family dining table is perfectly adequate, but cover it with a sheet of plastic first. Many inexpensive tables are available, or you can make your own from a large sheet of MDF and some trestles.

More or less any seat will do as long as it's comfortable, but an adjustable chair is better, especially for those with potential back problems. But whatever chair you use, the chances are that you will spend too long hunched over your work, so always stand up regularly.

LIGHTING

If you don't have good natural light, or want to work in the evenings, you will need a good light over your work table. Adjustable-neck lamps are ideal because they can be changed to different heights and angles. Daylight bulbs are available from most art stores in different wattages. They have a blue coloring to the glass to balance out the light color, and although they are more expensive than standard bulbs, they last a long time. Low-voltage halogen lights come a close second because they have a very bright white light. Halogen lamps also have the advantage of being small and lightweight, so you can hang them from a hook on a wall quite easily.

ADJUSTABLE-NECK LAMP
Position your light source so that you do not create shadow on your work.

STORAGE

As you accumulate equipment over the years, storage can become important. A good set of drawers will enable you to keep all your pencils, crayons, paints, erasers, knives, and rulers tidy, but you can improvise by using cardboard or plastic boxes to start with.

Some artists keep all their paper and boards, as well as finished artwork, in a chest of drawers called a flat file, which can be expensive. It's a lot more practical to keep one or two rigid portfolios propped against your wall to hold large sheets of paper and finished work.

STORING EQUIPMENT
It is advisable to keep your paints, brushes, and pencils together in one place. An art storage box is ideal.

CREATING YOUR FINAL IMAGE

Most illustrators start with a working sketch that they use as a basis for the finished artwork. Your sketch will usually be smaller than you want the finished painting to be, and may also be on paper unsuitable for painting, so you will need to transfer it to the painting paper at the right size.

TRANSFERRING DRAWINGS
The most cost-effective way to transfer a drawing is to draw a grid over your original sketch, either directly or as an overlay of tracing paper or acetate. You then make a larger grid in the same proportions on your final surface, copying each grid box one at a time.

If your sketch is the size you want the painting to be, simply trace it onto tracing paper, rub over the back with a soft pencil or graphite stick, place the tracing right side up on the final surface and go over the lines with a sharp pencil. An alternative is to use grease-free transfer paper, available from art stores, which is often more satisfactory and less messy.

Access to a photocopier with enlargement and reduction facilities is useful. If you have a computer and your sketch is not too large, you can process the image digitally. This gives greater control and opens up more possibilities. You can continue to alter your image and perhaps use distortion tools, if you have suitable software. When printed out, the sketch can then be transferred onto the final surface by

tracing as described above. If the paper you choose for the final drawing is thin enough, you can use a light box to trace the drawing. If you don't have a light box, a window can provide a strong light source—tape the paper to a window and trace away.

LIGHT BOX
A light box is a useful tool for transferring designs and patterns. The box has a translucent surface and is illuminated from within, providing a bright surface from which you can trace your work.

To create the paintings and drawings shown in this book or produce your personal versions of them, you will need a selection of the tools and materials shown here and on the following pages. These are the ones our artists have used, but if you have your own favorites or can't afford expensive equipment, use whatever is handy. Some of the images have been produced digitally, but, again, don't worry if you don't have the software, because all of them can be drawn and painted by traditional methods. The techniques associated with each medium are shown on pages 18–25.

PAPER

For making pencil drawings and rough sketches to try out ideas, use ordinary smooth white drawing paper, but if you want to work in color you will need a selection of papers tailored to your chosen medium.

DRAWING PAPER Ideal for pencil drawings and pen-and-ink work, but choose a good quality. Photocopy paper is an inexpensive alternative for trying out ideas.

LAYOUT PAPER Much thinner than drawing paper, and partially translucent, so it is good for refining drawings over several stages rather than repeatedly erasing the same drawing.

ILLUSTRATION BOARD Is used as a surface for creating artwork that will be scanned or reproduced onto other mediums. It has as many various textures as watercolor paper, so choose the surface to suit your requirements.

PASTEL PAPER Made especially for pastel drawings, it has enough texture to hold the powdery pigment in place. It is produced in a range of colors and can also be used for colored pencil drawings.

TRACING PAPER Useful for accurate tracing from photographs or other reference, and essential for light box methods (see page 13). However, pencil lines can smudge easily.

BLOTTING PAPER Placed under your drawing hand, this prevents grease and moisture from getting onto the drawing. It is also useful for removing excess paint.

SMOOTH (HOT-PRESSED) WATERCOLOR PAPER Can be used for most drawings and paintings including colored pencil and acrylic, but not suitable for wet watercolor washes or pastel work.

MEDIUM SURFACE (COLD-PRESSED) WATERCOLOR PAPER More heavily textured than hot-pressed paper, and the most popular choice for watercolor work or pen and wash.

A range of
watercolor papers

STRETCHING PAPER

Watercolor paper is made in different weights, or thicknesses, and you must stretch the lighter ones before using them or they will buckle when you apply the wet paint. Stretching your paper before painting will give you a smooth flat surface to work on. This surface will stay flat as you work, and the finished painting will dry flat. Stretching isn't difficult, and it means that you can economize by buying lightweight paper. If you can fold the paper easily, it should be stretched.

1. Cut four strips of gummed paper tape to the required length (to cover the edges of the paper) before wetting either it or the paper.

2. Wet the paper on both sides with a sponge, or soak it briefly in a basin or bath.

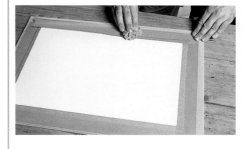

3. Wet the gummed side of the tape; then turn it over and stick it all around the edges of the paper, smoothing it with the sponge. Let it dry naturally.

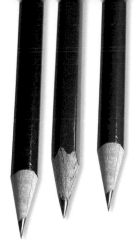

PENCILS AND ERASERS

Pencils are made in different grades, H denoting soft and B standing for black. There are several different types of erasers, but avoid very hard ones because they leave greasy smears and can damage the surface of the paper.

GRADES OF PENCIL
HB is in the middle of the range, and is a good all-arounder; 2B, 4B, and below are better for sketchy or expressive work.

MECHANICAL PENCIL
A useful alternative to wood-cased pencils because you can change the lead to suit your purpose.

ERASERS
A white plastic eraser is best for removing large areas of pencil. Remove debris with a soft brush before continuing with the drawing. A kneaded eraser can be pulled to a fine point to remove small areas and produce highlights.

Water-soluble pencils

COLORED PENCILS

Colored pencils are popular with illustrators, especially for detailed work, but the softer ones can also be blended for broader effects. They are made in a huge range of colors but can also be bought in boxed sets of 12 or more.

CHALKY COLORED PENCILS Can be blended for soft effects by rubbing with a rolled paper stump (see below) or a clean finger.
WAXY COLORED PENCILS Excellent for detail, but less easy to blend than chalky pencils. Both types can be mixed on the paper surface by laying one color over another.
WATER-SOLUBLE COLORED PENCILS Can be used dry, like a standard colored pencil, or spread with water to form a wash or simply to soften the lines.

PASTELS AND PASTEL PENCILS

Soft pastels, which crumble and smudge easily, are not well suited to detailed illustration work, and they also make a great deal of mess, requiring a dedicated work space—or a large dust sheet. Hard pastels and pastel pencils are more manageable, good for drawing over watercolor or acrylic to define detail and create areas of texture.

HARD PASTELS
These are good for covering large areas such as backgrounds because they can be used on their sides

ROLLED PAPER STUMP
Sometimes called a torchon, use this implement for blending small areas of pastel or colored pencil.

PASTEL PENCILS
Harder than the paper-wrapped pastels, but softer than colored pencils, these are easy to blend.

PEN AND INK

Drawing with a pen allows you to build up very fine detail and has the added advantage of not smudging. Pen and ink is often combined with watercolor or acrylic washes (see pages 22–25), but both pens and inks are made in a wide range of colors, so you can complete a whole drawing with inks.

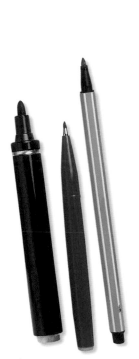

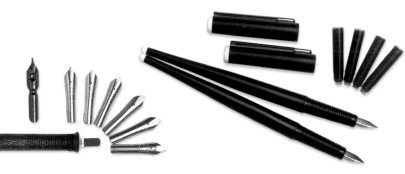

BALLPOINT AND ROLLERBALL PENS
Inexpensive and useful drawing implements, although available only in a limited point size. Rollerballs tend to be slightly wetter than ballpoints.

DIP PEN
Pen holder with interchangeable nibs, allowing you to make a variety of different lines. These pens are slow to use because they must be charged with ink after each stroke.

FOUNTAIN PEN
Metal-nibbed pen with ink cartridge. Delivers a constant flow of ink.

FIBER-TIP PENS
Available in different point sizes and a range of colors, these make a more mechanical line than metal-nibbed pens.

INDIA INK
Traditional ink for use with dip pens. Can also be applied with brushes.

WATER-SOLUBLE INKS
If used under watercolor washes, the ink will partially dissolve and spread out slightly to soften the lines.

ACRYLIC INKS
Can be diluted with water or mixed on a palette, but are completely waterproof when dry.

BRUSHES

Soft brushes, made from sable (expensive), synthetic fibers, or sable and synthetic mixtures, can be used for both watercolor and acrylic work. If painting with acrylic, make sure you wash the brushes thoroughly before the paint has had a chance to dry, or you will ruin them.

WATERCOLOR BRUSHES
There are two main shapes: rounds, which come to a fine point, and flats, which are good for large areas. Two rounds in different sizes and one flat are all you will need.

ACRYLIC BRUSHES
The bristle brushes made for oil painting can also be used for acrylic and are good if you apply the paint thickly. Nylon brushes, medium soft and springy, are the best choice for thin to medium applications.

Watercolor and gouache

Often thought of as a rather wishy-washy medium more suitable for painting flowers than fierce animals, watercolor is, in fact, capable of very strong, dramatic effects. It can also be combined with almost any of the other drawing and painting media, so if a watercolor goes wrong you can draw over it with colored pencil or paint over it with acrylic or gouache. The latter is the opaque version of watercolor, and the two are often used hand in hand.

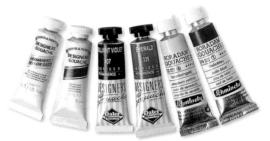

Palettes
Inexpensive plastic palettes are available, but ceramic ones are nicer to use. Don't use plastic palettes for acrylic because the colors will stain them permanently.

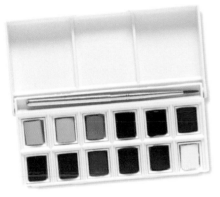

Tubes and pans
Watercolors can be bought as flat pans, in a ready-made paint box, or as tubes. The tubes are better for strong colors, but you will need some form of palette on which to squeeze them out.

Artists' and students' colors
All paints are made in two versions, with the artists' colors being more expensive because they contain more pure pigment. These are obviously best, but you could start with a small beginners' set of students' colors.

Gouache paints
These are sold in tubes, larger than the watercolor tubes. They can be mixed with watercolor, and white gouache is often used on its own or in mixtures for highlights.

Acrylic

This is the most versatile of all the painting media and you can achieve an amazing range of effects depending on the way you use it. You can lay thin, transparent washes of acrylic one over the other, or you can apply it thickly with a bristle brush or painting knife, mixing it with a bulking medium to thicken it. A number of acrylic mediums offer a range of consistency from pourable to moldable, with varying levels of transparency and finish.

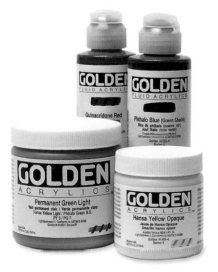

Pots and bottles
Acrylics can be bought in pots and lidded bottles that allow you to squeeze paint onto a palette. The paint is runnier than acrylics out of a tube.

Tubes
Acrylics are usually sold in standard tube sizes, except for white, which also comes in a larger size because you need more of it.

Drawing and Painting Techniques

Once you have your work space set up, you will need to think about which of the drawing and painting media best allow you to express your ideas, so look through the following pages for inspiration. One of the best things about drawing and painting is that you never stop learning. Some artists specialize in only one medium, pushing it to its limits; others find the huge variety available as exciting as the vision they are attempting to recreate.

There is always something new to try, and don't forget that most of the media can be used on their own or combined with others, as can the range of techniques. So carry out your own experiments until you find a way of working that you are comfortable with, allowing you to get down on paper the image you have in your head.

Graphite pencil

The ordinary "lead" pencil may seem a mundane implement, but the invention of the graphite pencil in the sixteenth century revolutionized drawing as artists quickly recognized its superiority over earlier drawing tools. Graphite pencils are probably the most versatile drawing instruments you will ever possess, so never underestimate them. They can provide almost endless variations of line and tonal quality and are made in a range of grades from very hard to very soft. Standard drawing pencils are encased in wood, but you can also buy just the graphite in the form of a thick stick, ideal for creating large areas of tone by using the side of the stick rather than the point.

Hatching
In this method, tones are built up with strokes following roughly the same direction. Darker shades are achieved by going over previous layers with heavier strokes.

Cross-hatching
Like hatching, this is a standard technique for any of the monochrome media. Hatching lines are laid first, and then another set of lines is added, crossing over the first. The denser and closer together the lines, the darker the tone.

Scribble
This technique can feel more natural than cross-hatching. Rather than making single strokes, keep the pencil on the paper all the time, using a loose zigzagging motion. Create dark and light tones by adjusting the pressure and overlaying.

Shading
Solid areas of tone and soft gradations can be created by using close-together lines made with a blunt pencil. You can soften the gradations even further by rubbing with a finger to blend the lines.

Eraser shading
Tones can be lightened and highlights achieved or reclaimed by lifting out pencil marks with a kneaded eraser molded to an appropriately sized point. Use either a stroking or stippling motion depending on the size of the area and the effect you desire.

Pencil grades
The range of tones can be increased by using different grades of pencil: hard for light areas and soft for dark ones. Lay the soft pencils over the hard ones, or you can use different grades for each area of a drawing.

COLORED PENCIL

If you want to use color but feel more comfortable with drawing than with painting, colored pencils are ideal. Several different types are available, some waxy and others chalky and thus easier to blend. If possible, try them out before using to discover which best suit your purpose—they are available individually as well as in sets. Watercolor pencils are a separate category. These are water soluble and can be spread with clean water to form a wash.

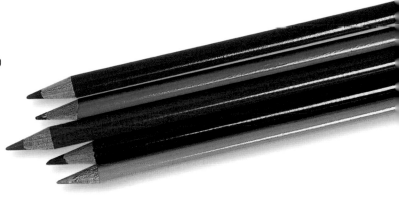

BLENDING BY HATCHING
By using different colored pencils and making hatching strokes in a uniform direction, you can create color changes and blends.

BLENDING BY CROSS-HATCHING
This method is excellent for delicate shading and color transitions. Variations in color strength can be created by changing the layers of the strokes and overlapping them at different angles.

SCRIBBLE BLENDING
This method, which is basically the same as scribble pencil drawing, can give a much denser and more textural shading and coloring effect. Colors are usually worked from light to dark.

RUBBING
Blending colored pencil by rubbing with a cotton swab, a rolled paper stump, or your fingers creates soft, blurred effects. The chalkier the colored pencil, the easier this is to do.

FROTTAGE
Placing the drawing paper on top of a flat, textured surface, such as a piece of loose-woven fabric, and shading with the colored pencils allows the underlying texture or pattern to come through.

WATER-SOLUBLE PENCILS
Also known as watercolor pencils, these allow you to combine watercolor techniques with line work. You can either lay down lines and then spread them with a wet brush or draw on wet paper.

IMPRESSING
If you indent the paper with a suitable tool, such as a fine paintbrush handle, and then draw over it, the indented lines will remain white. Here a blunted compass point has been used to create a pattern of fine lines.

LIGHT PENCIL INTO DARK PAINT
Light colored pencils can be used over dark watercolor or acrylic washes to create detail. Further paint washes can be laid on top and then more colored pencil, using a layering technique.

DARK PENCIL INTO LIGHT PAINT
Pale watercolor or acrylic washes can be worked into with darker colored pencils, picking out and enhancing details and textures.

DRAWING WITH INK

Drawing with ink is the oldest of all drawing methods. A wide variety of drawing pens are available, from dip pens with interchangeable nibs to many different types of reservoir pens, which contain their own inks. As with all drawing, experimentation is the key, since all pens act and feel differently in your hand. Fiber-tip pens deliver a constant flow of ink; traditional metal-nibbed pens give more variation in line. Ink drawings, whether in pen or brush, can't be corrected later, so experiment with a variety of implements to discover the marks they make before using inks for a finished drawing.

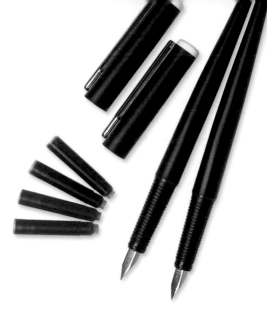

NIBBED PEN
A nibbed pen with its own ink cartridge (fountain pen) can be used to produce very detailed and tight drawings or loose expressive sketches. The consistent flow of ink can make it easier to control than a dip pen.

DIP PEN
A dip pen has to be repeatedly dipped into the ink, resulting in more uneven lines, but the drawing style can be scratchy and energetic. A variety of different nibs are available, in assorted shapes and sizes.

BRUSH AND INK
Drawing with a brush produces a fluid and organic line. The lines can be fine or broad depending on the weight of the stroke, and light tones can be achieved by "starving" the brush of ink at the end of a stroke.

FINE-POINT MARKER
These fine reservoir pens deliver a very consistent and rather mechanical line, although drawing on a soft surface can help create some variation. Very dense cross-hatching can be made with these pens.

RAPIDOGRAPH
Available in several point sizes, rapidographs are primarily used for technical drawing, but can be used to sketch and are especially useful for creating quirky, scratchy lines. The ink is waterproof and the lines constant.

LINE AND WASH
The classic technique is to draw the ink lines first and then add color to create all but the darkest shades. This can feel more spontaneous than drawing over washes.

INK OVER COLOR
Black ink pens can be used over larger colored washes to pick out shapes and create form. This method is useful when creating random natural detail, with the pen following the shapes created by the color washes.

COLORED LINE
Drawing pens are made in a variety of colors, as are drawing inks. Using a series of colored lines, either with a fine-point marker or a nibbed pen, can create a range of different effects and colored surface textures.

BALLPOINT PEN
These everyday implements are excellent for quick, spontaneous sketching or working into more complicated drawings in conjunction with other pens. Even black ballpoints can vary in shade, some creating quite gray lines, as in this case.

COLORING WITH INK

Drawing inks come in a wide range of colors, so there is plenty of scope for using them to color your beast. Colored inks are transparent, so colors can be mixed on the picture surface by laying one on top of another. Bottled inks can also be mixed on a palette and diluted with water to produce different tones. Inks should be worked from light to dark, but you could modify a dark color by working a lighter one on top. If mixing on the paper, avoid building up too many colors because this can cause muddying. Ink will sink into watercolor papers but sit on top of the grain of smooth paper, producing more solid colors.

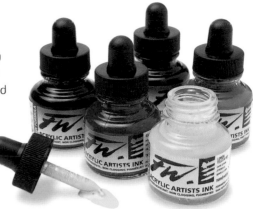

ACRYLIC INK
This is waterproof when dry, making it possible to work repeated layers of wet-on-wet without disturbing the colors beneath. The pigment in these inks is very fine and does not clump together as much as other inks, giving a finer spread of color.

LIFTING OUT
Removing color with a tissue or dabbing into it while still wet can create soft highlights or interesting effects.

PULLING OUT COLOR
If you draw quickly with a pen and waterproof colored ink, then use a wet brush to pull color away from the line, you can achieve a pen and wash effect.

WATER-SOLUBLE INK
This remains soluble in water even after it has dried, allowing lines to be softened or spread out into washes. You can buy water-soluble inks for dip pens or use a fountain pen, as in this example.

WAX RESIST
Lovely effects can be gained by making a drawing in pale wax crayon and laying ink on top. The ink will slide off the waxed areas; the stronger the wax mark, the greater the resist.

LAYERING COLORS
Waterproof inks are the best to use for layering methods because the new colors will not disturb earlier ones. As with watercolor, work from light to dark.

DRY SPONGING
A dry sponge can be used to lift ink laid on wet paper to create subtle color and tone changes. Different textures of sponge will influence the effects you can achieve.

WET SPONGING
Sponges can also be used to apply ink, creating interesting random textures. Several layers could be applied, in different colors.

SCRATCHING
Distressing the surface of the paper in controlled areas provides a rough texture. Here, ink has been laid over scratched paper and then rubbed with the side of a colored pencil to bring out the marks.

WATERCOLOR

Watercolor techniques could fill an entire book on their own; there is only enough space here to deal with the basics. Many of the methods, such as wet-on-wet and lifting out, are the same as those shown for inks on pages 20–21, but do remember that watercolor remains water soluble even when dry, so too many layers can stir up the colors beneath and become muddy. Watercolor is perhaps the simplest of the painting media, requiring little equipment at the outset, yet its simplicity is its greatest asset because it can be used just about anywhere. A watercolor set can be kept in a pocket, making it ideal for work on the move as well as in the more controlled environment of a studio space.

GRANULATION
Unlike inks, some watercolor pigments do not fully dissolve in water, resulting in a grainy effect that can be useful for textures.

CONTROLLED WET-ON-WET
To achieve interesting and soft color transitions within one controlled area, lay the first color and then drop in more paint while still wet. The paint will not spread onto the dry paper.

MAKING RANDOM PATTERNS
This is a variation of the lifting-out method shown for inks. Intriguing patterns can be created by dropping a loosely crushed tissue onto wet paint. The effect is sharper in watercolor than ink.

DRIPPING ON WATER
Dripping water onto semidry paint causes the color to "run away," creating jagged-edged blotches that might be ideal for rock or foliage textures.

IMPRESSING
A good natural texture effect can be obtained by pressing several tissues down hard on a partially dried area of color.

CLOUDY EFFECTS
Amorphous shapes can be created by brushing on an area of flat color, leaving it to dry and then going over it with clean water and removing it with a quick dab of a tissue.

WATERCOLOR OVER WAX
This method is the same as that shown for inks, but the resist effect is much cleaner and crisper with watercolor. The pressure of the wax crayon can be varied, as in this example.

WATERCOLOR AND PENCIL
Using pale washes of watercolor to color a sketch in pencil can be a very quick way to arrive at an interesting and vivid finish. Layers of color can be laid over one another to mix on the paper surface.

INDENTING
Pressing lines into the paper with a semisharp implement, or scratching with a knife, will cause the paint to run into the indentations and create clear dark lines.

WATER PATTERNS
In this example, a featherlike pattern of clean water has been painted onto the paper and color applied on top so that it runs into the shapes. This can be done in several stages to build up complex patterns.

WATER SPATTER
Mottled effects can be achieved by applying heavy color and then spattering clean water onto it from a brush or toothbrush.

STIPPLING
The traditional method is to build up an area with small strokes made with the tip of a pointed brush, but a similar effect can be obtained by dabbing with a sponge. For a soft effect, you can work on damp paper.

DRY BRUSHING
This method, often used for foliage, involves using the minimum of paint on the brush and dragging it over the paper so that the color does not sink in.

COARSE SPATTERING
Flicking on the paint with a large or medium sized watercolor brush creates large random splashes of color.

FINE SPATTERING
For a fine and easily controlled spray, a toothbrush is the best implement. Load it with paint and then drag a ruler or paintbrush handle over the bristles.

SPATTERING ON WET PAPER
Spattering onto wet paper creates softer speckled effects because the spattered color spreads out slightly. The heavier the pigments, the more concentrated and isolated the speckles.

BLOTTING OUT
Leaving a spattered area to dry for a few minutes and then removing the wettest areas with blotting paper can create an interesting outline effect around each of the spattered droplets.

BLOTTING WITH A BRUSH
An outline effect can be achieved by blotting out spattered areas with a brush.

TONAL VARIATIONS
Transitions of tone can be obtained by tilting the board so that a large blob of color settles toward one edge of the shape, and then removing the remaining area of wet pigment with blotting paper or tissue.

COMBINED METHODS
A combination of blotting and wet-on-wet has been used here. Colors were painted on, allowed to merge, and then dried partially before being washed over with clean water and blotted with tissue.

ACRYLIC

Acrylic is the most modern of all the painting media, using synthetics rather than natural oils or gums to support the pigment. It can be applied thickly like oil paint—but has a far shorter drying time—or applied in thin washes or glazes like watercolor, with the advantage of being waterproof when dry. It is water soluble and diluted in water, but manufacturers also produce a large range of different mediums to make the paint more transparent, thicker, or textured in various ways. Acrylic color is lightfast, more or less impervious to damage once dry, and can be used on any porous surface. It is the clear choice for anyone working on a tight budget, because a single set of paints can be used to mimic all the others.

WET-ON-WET
To achieve watercolorlike wet-on-wet effects, acrylic must be diluted with water. The pigment is more fibrous than watercolor and tends to clump together, but acrylic matte or gloss medium will help to prevent this.

WORKING ON WET PAPER
Thicker paint, the consistency of heavy cream, will also spread out on wet paper. The degree of spread depends on the consistency of the paint.

RANDOM TEXTURE
By applying thick paint on wet paper or board, random textures can be achieved over large areas.

WET-ON-WET LAYERS
Because acrylic is completely waterproof once dry, you can build up successive layers of wet-on-wet to create complex color effects.

WET-ON-WET OVER FLAT COLOR
You can paint wet-on-wet, using diluted paint, over areas of flat color that have been allowed to dry.

OPAQUE APPLICATIONS
Thick opaque color can be worked over other layers of opaque color. By applying clean water between the layers, the new colors can be worked into previous ones, creating random textures.

WATER INTO PAINT
Thick opaque paint that is still wet can be worked into with a brush loaded with clean water. This can be done over many layers.

BLOTTING
In this example, a layer of opaque color has been painted over a dry layer. The second layer of color is removed by blotting.

PAINTING WITH A KNIFE
Smearing on medium-consistency paint with a palette knife over a dry layer allows some of the previous color to show through.

PAINTING WITH CARD STOCK
An alternative to a palette knife or painting knife is a piece of stiff textured card stock. Plastic cards are also useful for applying thick or medium-consistency paint.

ACRYLIC MEDIUM
Acrylic mediums, sold in bottles and available in both gloss and matte finishes, increase the transparency of colors without altering the consistency of the paint.

TEXTURE EFFECTS
A flat area of acrylic mixed with a medium can be lifted with a variety of materials to create texture. In this example, a piece of plastic wrap was used, but you could also try a rough-textured fabric or crumpled aluminum foil.

BROKEN-COLOR EFFECTS
Thick opaque paint mixed with medium can be blotted out any number of times before it has dried, creating several layers of broken color.

EDGE QUALITIES
Brush strokes of thick paint, either on its own or mixed with a bulking medium, will dry with distinct edges and ridges. These can be highlighted by laying a transparent wash on top.

IMPASTO
By laying thick wet colors over one another with a palette knife or painting knife, you can create interesting color-change effects because some parts will mingle.

CRACKLE GLAZE
This is an acrylic medium available from most craft stores. It is a transparent acrylic glaze that dries at a different speed than the paint, causing cracks to appear. Thick paint, as used here, will develop fewer cracks.

CRACKLE GLAZE WITH THIN PAINT
In this example the paint is thinner and the crackle effect more obvious.

DRY BRUSH
Paint has been mixed onto the brush and then mostly removed before dragging gently across the surface. A minimal amount of paint adheres to the texture of the surface.

IMPASTO AND DRY BRUSH
Combining techniques can create interesting effects. Here thick impasto was laid as the base texture, followed by alternating layers of dry brushing and transparent washes.

SPRAY PAINT UNDER ACRYLIC
Acrylic aerosol sprays make an interesting base coat for working over with normal acrylic paints.

SPRAY PAINT OVER ACRYLIC
Aerosols can also be used over areas of acrylic paint, with the fine spray causing colors to merge more subtly.

Working Digitally

Your choice of computer is your preference. Apple Macintosh is the preferred system among digital drawing professionals, but most industry-standard software is available on both Mac and PC. Most PC operating systems include a program that allows you to draw, paint, and edit images. Microsoft Paint, for example, is part of Windows, and although slightly primitive, it is a good place to start experimenting with digital drawing. You can draw freehand and create geometric shapes, pick colors from a palette or create new custom colors, and combine visual images with type. Scanners also include a basic photo-editing and drawing package or a reduced version of one of the more professional packages.

Tools and equipment

As you begin to discover the possibilities of drawing on-screen, you will probably want to upgrade to more sophisticated software. A wide choice is available, although some programs can be expensive. However, as these are continually being revised and improved, it is often possible to pick up older versions quite cheaply. One of these is Painter Classic 1, which is easier to use than the more complex later versions and offers a wide range of drawing implements. Another is Photoshop Elements, which, although basically a photo-editing program, also allows for the production of original drawn and painted images. The other vital piece of equipment is a stylus and drawing tablet. Drawing with a mouse can be awkward and clumsy because it is held quite differently from a pencil or pen, whereas a stylus replicates the natural drawing movement. Tablets come in a range of sizes, with commensurate differences in price, but smaller ones are well within the budget of most artists.

Scanner
Most scanners have high optical resolutions that are adequate for scanning line work to be colored digitally.

Graphics tablet
A graphics tablet offers a more natural way of working than using a mouse.

Computer
The Apple iMac is an ideal computer for digital artists.

PHOTOSHOP

There are three ways to select colors in Photoshop: selecting from a standard or personalized grid (1), mixing colors using sliders (2), or picking from a rainbow color bar (3). It is also very easy to match a color in your work by clicking on the picker tool (4) and then on the color you wish to match. The foreground and background boxes in the tool bar (5) used with the large color picker (6) give you control over areas of color. There is a range of standard brushes and drawing tools and options for customizing them (7). The tool bar also has the usual digital equipment, including selection, drawing, and cloning (8).

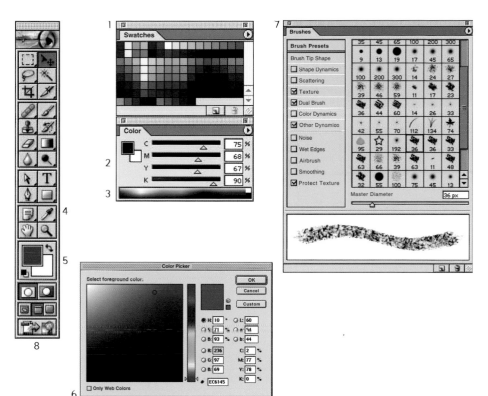

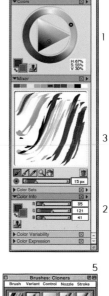

ILLUSTRATOR

Illustrator offers color options for linear work and solid areas. Colors can be selected in three ways: by picking off a color grid (1), using sliders of the constituent colors (2), or selecting from a rainbow color bar (3). There are also options to specify the weight and fill of the line (4). The usual range of standard or customized brushes is available (5), as is digital equipment such as selection, drawing, distortion, and cloning (6).

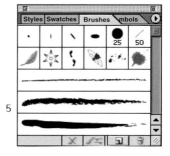

PAINTER

Color options in Painter are more sophisticated than those in Illustrator and Photoshop. The color selector (1) allows you to choose tone with the central triangle and control the hue with the outer color wheel. Color can also be chosen with sliding bars (2) and tested in a sample window (3). You can match colors with the picker tool (4). Various drop-down menus (5, 6, 7) give you control over surface, drawing implement, and the sharpness or texture of the implement.

BITMAP AND VECTOR IMAGES

Most software applications designed for image editing and painting use bitmap images, but some programs—usually titled Draw rather than Paint—support vector graphics. For pixel-based software, most people use Adobe Photoshop, but Corel Procreate Painter offers good imitations of natural media such as watercolor or pastel. Vector programs such as Adobe Illustrator or Macromedia Freehand are great for working with flat color and precise lines. Corel Draw offers pixel and vector tools in a single package.

Bitmap or raster image at
100% and 400%

Vector image at 100%
and 400%

Vector images are made of curves, lines, and shapes defined by mathematical equations. This means that they are resolution independent and can be enlarged without losing definition.

This dragon silhouette was produced in Corel Draw. The small squares are fixed points that can be moved, and the lines in between them stretched to alter the curves. This is ideal for producing simple line images.

If you zoom in on a scanned photograph or piece of computer artwork, you will see that the image is made up of a mosaic of colors. These are called pixels. Images made up of pixels can create very subtle gradations of tone and hue. However, because each image contains a set number of pixels, they are resolution dependent—they will lose detail and appear ragged (pixelated) if they are enlarged too much. To avoid this you should produce your artwork at a high enough resolution to suit the size of the final art. Three hundred dpi (dots per inch) at actual size is usually sufficient. In Photoshop you can set this in "Image," "Image size," "Document size." Before you start painting, enter the width and height at which you would like to print your final artwork, and then set the resolution to 300 pixels/inch.

DRAWING AND PAINTING MEDIA

Any software designed for drawing and painting will provide a range of tools, from pens, pencils, pastels, and colored pencils to various brushes. Painter, for example, has a vast range of brushes and drawing implements, letting you work in more or less any media you choose. In Photoshop the airbrush tools give varying effects by changing the opacity and pressure and permit you to spray one color over another.

Programs vary, but most have a swatch tool you can pick colors from. The eyedropper tool enables you to select a particular color from your picture for use elsewhere in the composition. The dodge and burn tools in Photoshop enable you to lighten and darken previously painted areas of color and create shadows and highlights.

When learning a new piece of software, familiarize yourself with the different tools and their effects by doing some doodling with them. You may find it easiest to draw an initial sketch by hand on paper and then scan this image in to be digitally colored.

PAINTER BRUSHES
Painter has lots of art brushes that replicate actual brush strokes and different media. The sample here shows different brushes including oil, airbrush, acrylic, watercolor, and charcoal.

PHOTOSHOP BRUSHES
When you are using the brush tool in Photoshop, you can set the type of brush and size in the brush toolbox. To view this, click "Brushes" in "Windows," on Photoshop's top tool bar. The green marks represent different airbrush sizes. The blue marks show a marker pen-style brush. The pink marks show the more unusual brushes that produce a particular preset shape many times.

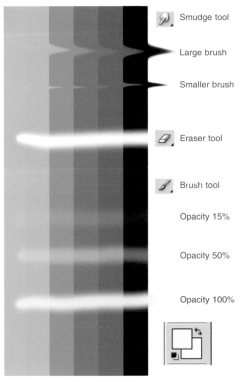

Smudge tool

Large brush

Smaller brush

Eraser tool

Brush tool

Opacity 15%

Opacity 50%

Opacity 100%

BRUSH SMUDGE

There are various ways to paint in Photoshop. The swatch here shows the smudge tool, which can be used to blend or move areas of color, plus the eraser tool and the brush tool. The brush tool can be altered in size and opacity. The lower you set the opacity, the more diffuse the color you will be adding.

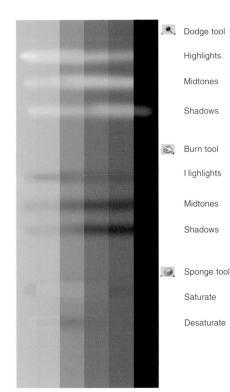

Dodge tool

Highlights

Midtones

Shadows

Burn tool

Highlights

Midtones

Shadows

Sponge tool

Saturate

Desaturate

DODGE AND BURN

The dodge and burn tools are very useful for adding highlights and shadows to existing areas of color. The highlights, midtones, and shadows settings alter the levels at which the tones are affected. The sponge tool will increase or decrease the intensity of an existing color.

Hue/Saturation
Colorize

Hue/Saturation
Colorize

Brightness/Contrast
Brightness down

Brightness/Contrast
Brightness up

Brightness/Contrast
Brightness down

Brightness/Contrast
Brightness up

Invert Opacity 100%

HUE BRIGHTNESS

By selecting a particular area of color, you can alter its shade, brightness, and saturation. These functions can be found by clicking on "Image," "Adjust," followed by the function you require.

FILTERS

Filters can be applied to an image to create interesting effects. The image above has been created by drawing with the brush tool. The images to the right are the same images, with filters applied. To achieve the top right image, go to "Filter" on Photoshop's top tool bar, then "Distort," then "Twirl." You can adjust the level to which your image is distorted in the box that appears. The middle right image is the result of "Filter," "Texture," then "Stained Glass." The bottom right image was created using "Filter," "Sketch," then "Chalk and Charcoal."

COLORING WITH PHOTOSHOP

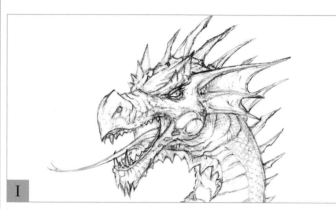

1

This beast has been drawn by hand and then scanned into Photoshop. You can draw on the computer, but it can be difficult to get a good flow of line even using a graphics tablet, and many digital artists still prefer to sketch by hand. The dragon has been cut out from the white background. The background was selected using the magic wand tool. The image of the head has been placed on a separate layer (see page 32) so that future functions will affect the head only, and leave the background white.

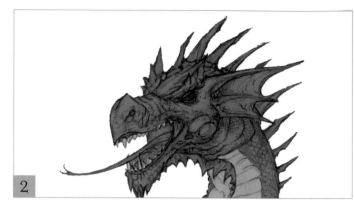

2

By altering the levels in the Hue/Saturation function, the whole head has been shaded dark pink. The main areas that are to be different colors have then each been selected using the lasso tool, and individually colored using the Hue/Saturation function.

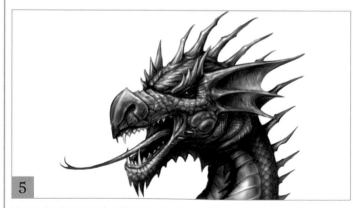

3

Using the burn tool, shadows have been put onto the previously flat areas of color.

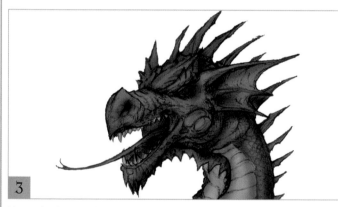

4

Using the dodge tool, highlights have been added. The edges have been cleaned up using the eraser and smudge tools.

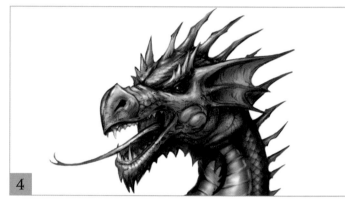

5

Using the brush tool with 20% opacity, different colors have been added over the top of the image to give more variety of color. The head has been "selected" so as not to affect the surrounding area. More smudging and further use of the dodge and burn tools on a small brush setting give the details.

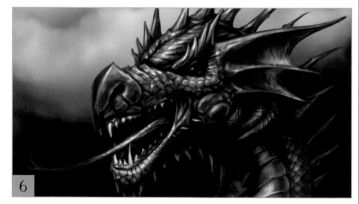

6

A background has been added to complete the picture. The separate white background layer is behind the dragon's head and therefore can be altered without affecting the dragon itself (see page 32). Various shades of orange have been sprayed on with a large setting brush to create this volcanic cloud effect. The colors have been picked from the "Swatches" box, which you can access by going to "Window" and ticking the "Swatches" option. Whatever swatch of color you click on will be selected for use with the brush.

COLORING WITH LAYERS

Most drawing, painting, and photoediting programs allow you to experiment with different effects and compositions by using layers. Layers can be visualized as pieces of transparent film stacked on top of one another. When you make a drawing or scan in a photograph, it appears as a background layer called the canvas. If you create a new layer on top of this, you can work on it without altering the underlying image because the layers are independent of each other. Similarly, you can work on the canvas without affecting any images on other layers.

Layers are especially useful for collage-type compositions, in which images, shapes, or textures are superimposed over others. This type of work involves making selections, which is the digital equivalent of cutting out a shape with scissors. Suppose you want to paste a drawing of a beast onto a hand-painted, textured, or photographic background. You would start with the background in the canvas layer, draw around the chosen image with one of the lasso tools to select it, and put it into a new layer (usually you will find a menu command such as "Layer via selection").

Selection is one of the main elements of digital work. It is the way you isolate the area that you want to work on. You can combine as many selections as you like in one image, and they don't have to be drawn or photographic—you could make collages with pieces of digitally colored or textured pieces of paper, or found objects such as leaves that you can scan in. To try out different juxtapositions, you can change the stacking order of the layers at any time, and you can apply various effects to individual layers as well as alter the color and opacity.

PAINTER

The Layers palette will help you organize your work, and if you make a mistake it is easier to rectify because you are dealing with only one layer at a time. If you are working with lots of layers, make sure you name them. The selection tools contain the normal marquee tool (1), both round and circular, a lasso tool (2), a magic wand (3), a color picker (4) for selecting items of the same color, and a tool for resizing the selection (5).

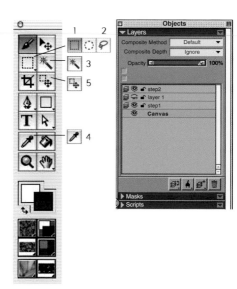

PHOTOSHOP

One of the most useful functions in Photoshop is the ability to put different elements on different layers. The Layers window (see below) allows you to turn the visibility of each layer on or off and to adjust transparency using the opacity percentage slider. A number of tools are available to select various parts of the image, all of which are found in the toolbar (1). The marquee tool (2) is useful for simple geometric shapes, the lasso tool (3) for drawing around chosen areas, the magic wand (4) for selecting areas where the color or tone is distinct, the picker tool (5) to sample a color that is linked to a selection dialog box, which allows you to adjust the range of the selection through the fuzziness slider, and the quick mask tool (6), which allows you to paint a selected area.

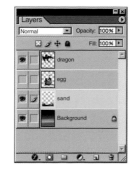

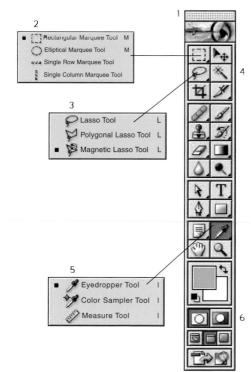

USING LAYERS IN PHOTOSHOP

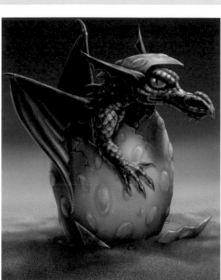

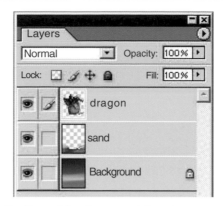

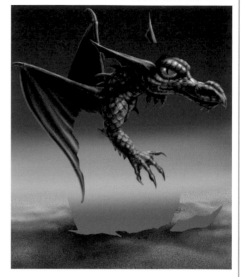

This dragon has been created on four different layers—the dragon, the egg, the desert sand, and the background.

The "Layers" box is accessed through "Windows" on Photoshop's top tool bar, then clicking the "Layers" option. You will see a small thumbnail of the object on each layer displayed on the appropriate bar. The layer you are working on will be highlighted in blue. To change layers, just click on the one you want. You can alter the layer order by dragging one layer above or below the others in the list. Where an upper layer overlaps a lower layer it hides any of the layer that is behind it, so it is therefore important to get your layers in the right order. For example, here the sky is at the back (bottom of the list). The sand is on top of this, followed by the egg and dragon.

Here the egg layer has been hidden, revealing the background behind it.

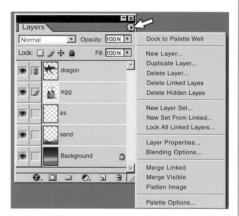

Linked layers can be combined into one layer. To do this, make sure the required layers are linked, then click on the small arrow in a circle on the top right-hand corner of the Layers box and click on "Merge Linked."

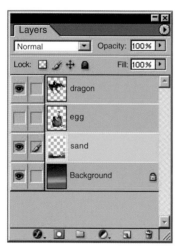

To hide a layer, click on the eye symbol to the left of the window. Here you can see the eye on the egg layer is missing. To bring the layer back into view, click on the eye box again and it will reappear.

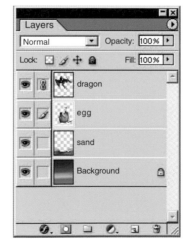

Here two layers have been linked together. You can see the link symbol in the dragon layer, which is now linked to the egg. If the egg is moved, the dragon will also move. To add or remove links, click on this link box.

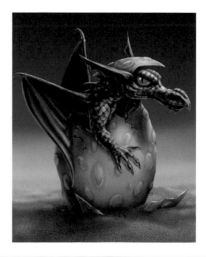

The new combined layer is now shown (right).

SELECTING AREAS OF COLOR

By using the magic wand tool, you can select particular areas of color. The tolerance of the tool can be altered so it detects a greater or lesser range of color. In the image on the far right, the wand was clicked on the blue of the eye at a tolerance of 80 and selected all the shades of blue in this area. An effect was then applied to this selection. As seen in the image beneath it, the Hue/Saturation was altered to green.

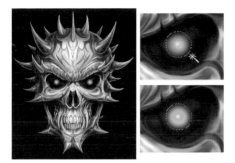

 You can also select areas using the lasso tool, by drawing around the area you want with it. Zooming in on a particular area will help you select the areas you require more accurately. You can select and place different parts of the image on separate layers, as shown on page 32. Functions and effects can then be performed on the different layers and the rest of the image will remain unaltered.

CREATING SYMMETRICAL IMAGES

In Photoshop images can be duplicated and flipped, offering great potential for symmetrical images. This could be used to create a beast with a symmetrical head or for producing images such as a coat of arms.

The easiest way to ensure that an image is symmetrical is to create half of it, then duplicate it and flip it over. Here, the half shield has been drawn on a separate layer from the background. To copy the half shield, make sure you are on the correct layer (your selection will be dark blue in the Layers box), then go to "Layer," "Duplicate Layer." The Layers box will show your different layers.

To produce a right-hand side, select the copied layer and go to "Edit," "Transform," and then "Flip Horizontal." Move the flipped layer to align with the existing half to create the shield. Holding the shift key down when you move your layer will help you keep it in the same horizontal plane. Zoom in on the shield and make sure the two halves are correctly aligned, then combine these two layers into one.

To make the shield more three-dimensional, an effect has been added. Go to "Layer," "Layer Style," and then "Bevel and Emboss." A box will appear in which you can set the size and depth of your bevel. The Layers box will show your layer with the Bevel and Emboss function on it. To alter this you can click on the white "Effects" bar shown below the layer.

The stylized dragon will form part of the coat of arms and has been added on a separate layer.

The dragon is then duplicated and flipped and placed to the right of the shield.

Various other elements have been added to the design to complete the heraldry. Each element is on a separate layer, so you can move the elements around until you are happy with the balance of your design.

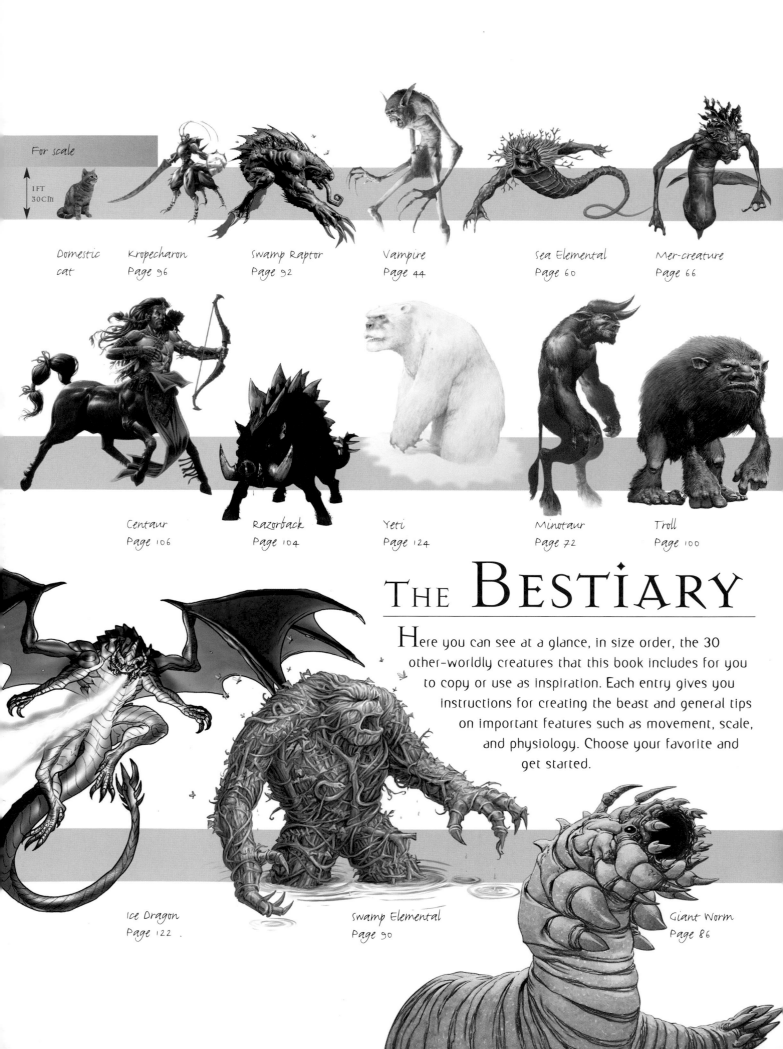

For scale

1 FT
30 CM

Domestic
cat

Kropecharon
Page 96

Swamp Raptor
Page 92

Vampire
Page 44

Sea Elemental
Page 60

Mer-creature
Page 66

Centaur
Page 106

Razorback
Page 104

Yeti
Page 124

Minotaur
Page 72

Troll
Page 100

The BESTIARY

Here you can see at a glance, in size order, the 30 other-worldly creatures that this book includes for you to copy or use as inspiration. Each entry gives you instructions for creating the beast and general tips on important features such as movement, scale, and physiology. Choose your favorite and get started.

Ice Dragon
Page 122

Swamp Elemental
Page 90

Giant Worm
Page 86

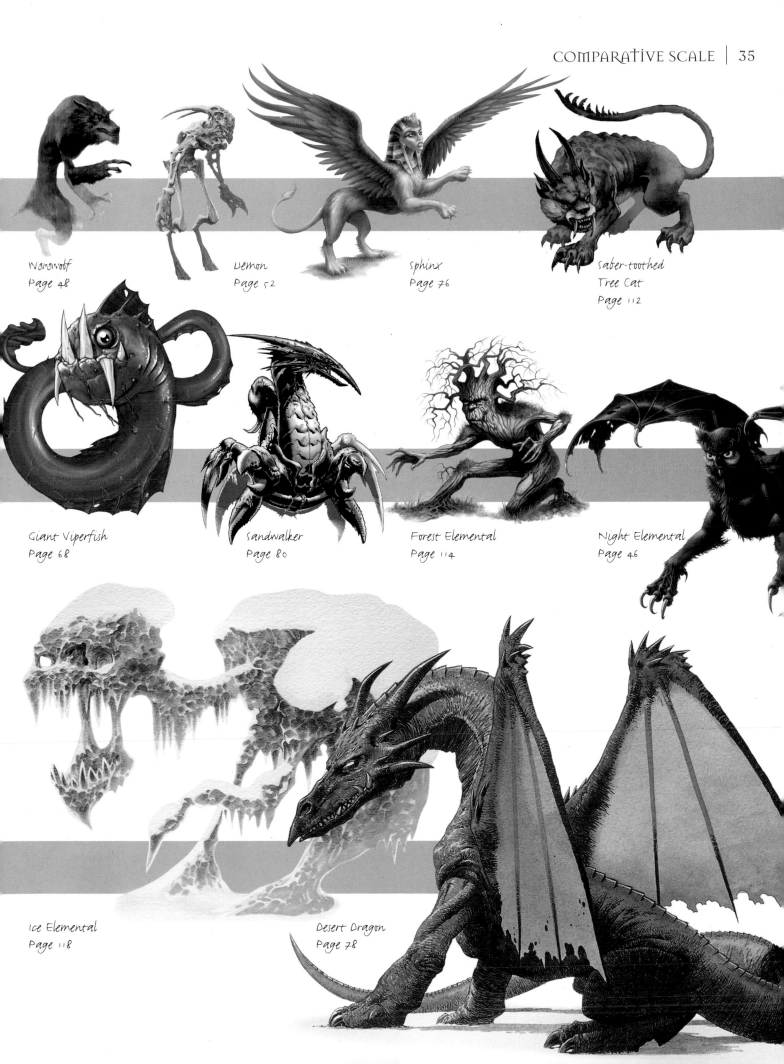

Werewolf
Page 48

Demon
Page 52

Sphinx
Page 76

Saber-toothed
Tree Cat
Page 112

Giant Viperfish
Page 68

Sandwalker
Page 80

Forest Elemental
Page 114

Night Elemental
Page 46

Ice Elemental
Page 118

Desert Dragon
Page 78

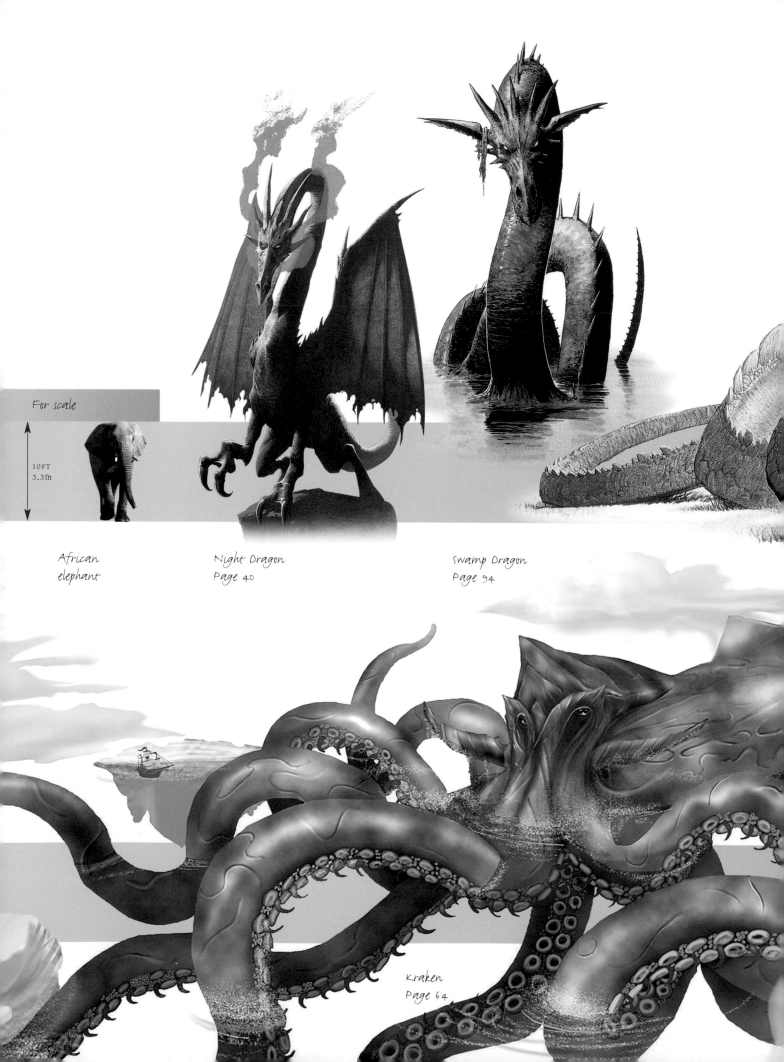

For scale

10 FT
3.3 m

African
elephant

Night Dragon
Page 40

Swamp Dragon
Page 94

Kraken
Page 64

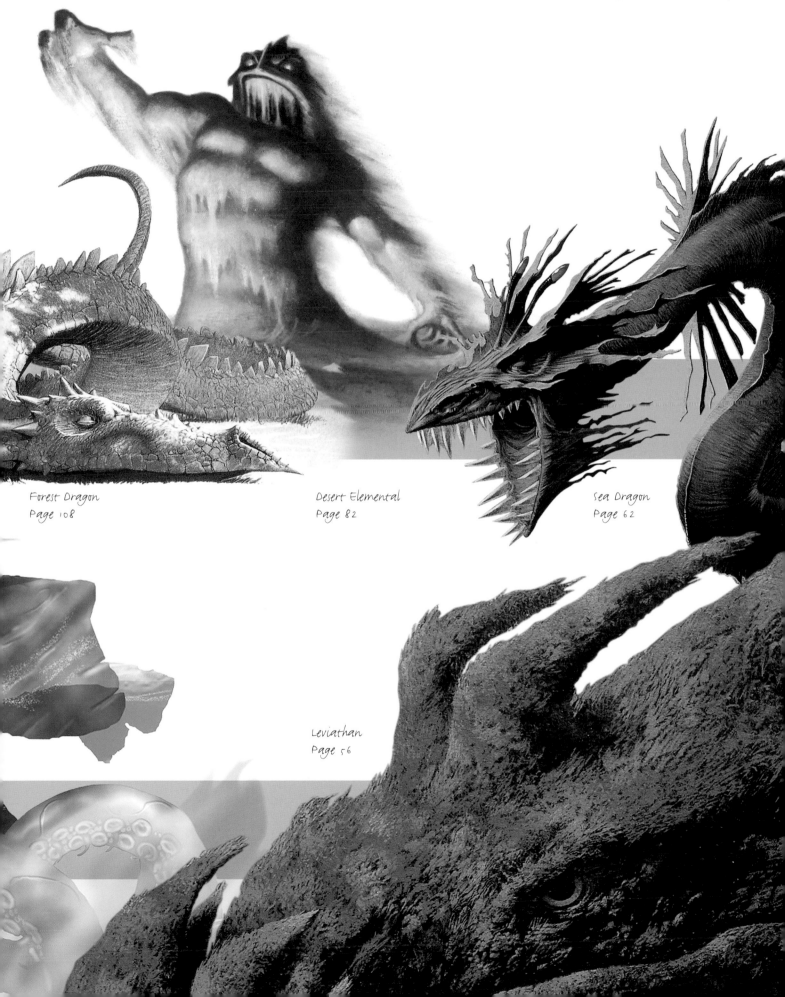

Forest Dragon
Page 108

Desert Elemental
Page 82

Sea Dragon
Page 62

Leviathan
Page 56

Night Beasts
Getting Inspiration

Many known and unknown beasts use the cover of darkness to hide their activities. Nocturnal creatures can be quiet and meek or predatory and dangerous. Nature programs on television can give you ideas.

1 Stormy weather can be as inspirational as darkness. Together they represent dark and powerful forces at work.

2 Some creatures, although fairly harmless in reality, conjure up fear by virtue of nocturnal activities. Most bats are gentle, passive creatures, but their reputation is just the opposite.

3 Sketch skeletons in order to build up your physique drawing skills. Your local museum will have some for you to look at.

4 Creatures that undergo a complete metamorphosis, like this moth, can really stir the imagination, offering two fantasy beasts in one.

1

2

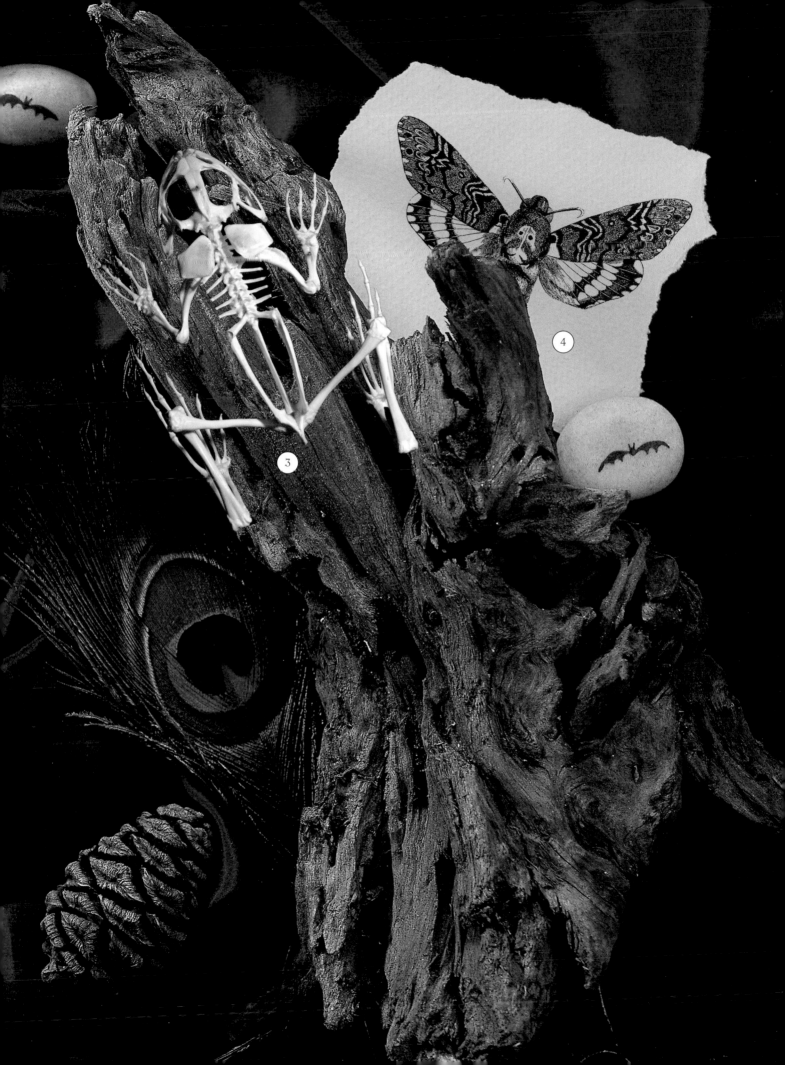

CHARACTER SKETCHES: Night Dragon

The dragon is one of the oldest mythological creatures. It has a widespread history, appearing in the traditions of virtually all countries and continents back to the beginning of time.

A dragon can be passive or aggressive, so the pose is extremely important. The form of the dragon is defined by its limbs, which can allude to the environment in which it lives—a water dragon, for example, may not need limbs at all. Other attributes, such as the neck length and whether it has wings or fire-breathing abilities, and so on, are the artist's personal choice.

This dragon is completely nocturnal, feeding on much smaller creatures than its size might suggest. It stands around the same height as a giraffe and nests in volcanic craters. It is known as a "smoker" because it does not actually breathe fire; its pyrogastric gland is located too far down its neck to cause its breath to combust. It is theorized that fire breathing has evolved out of this dragon because it relies on stealth and noxious fumes to incapacitate its prey.

PHYSIOLOGY FACT FILE

Size:	Up to 69 feet (21 meters) long
Weight:	2.5 tons
Skin:	Dark blue-black
Eyes:	Violet (self-illuminating)
Signs:	Mass gas poisoning; acid rain in vicinity

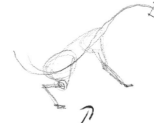

DRAGON POSE
The dragon pose is based on a symmetrical curved line. Like a dinosaur, the tail counterbalances the head.

The more complicated the curve, the more action-packed the pose.

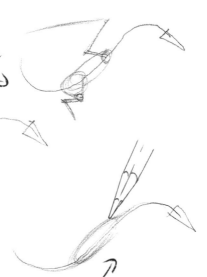

DRAGON FORMS
There are five basic dragon forms, defined by the limbs:
1. Large hindquarters and large forelimbs. The wings are optional.

2. Large hindquarters and small forelimbs. The wings are optional.

3. Large hindquarters with wings as forelimbs.

4. Large hindquarters and no forelimbs. The wings are optional.

5. No limbs, wings are optional.

WINGS

A dragon's wing, like that of a bat or a bird, should be shown as an arm that has evolved into a wing: It should have the same joints as an arm. Think of the wings of a dragon as a built-in hang-glider.

vestigial

wrist

elbow

shoulder

FORESHORTENING

Foreshortening an object, especially something flat, like a dragon's wing, will give the impression of it being placed at an oblique angle to the viewer.

To discover what the shape might look like at such an angle, draw the full shape on a small piece of paper, then tilt it in at the required angle and copy what you see. When filling out the form, remember that lines and shapes become closer together toward the back, so start with the part closest to you, then position the farther shapes behind those at the front.

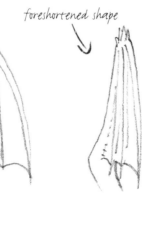

fingers

foreshortened shape

flat shape

EVOLUTION

The fingers have no joints, which is necessary in order to tighten the skin membrane between the fingers. Also, they do not need to articulate, so any joints have evolved out. The thumb becomes vestigial—a primary horn, with other growths clustering around it. The fingers themselves would be light, and probably made of cartilage in order to be flexible. Articulated bones would be heavier and would require complicated muscles and tendons to function, making the wing heavy and impractical.

SEE THE ARTIST AT WORK ▶

COMPARING SKETCHES

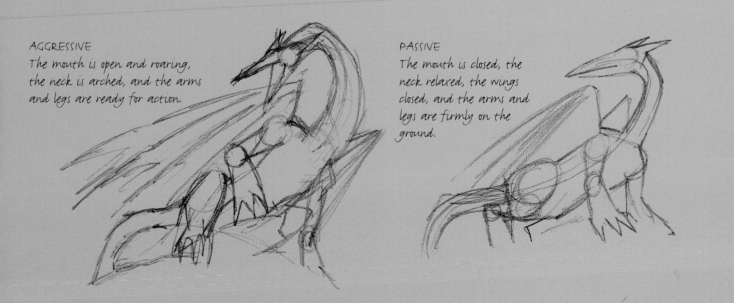

AGGRESSIVE

The mouth is open and roaring, the neck is arched, and the arms and legs are ready for action.

PASSIVE

The mouth is closed, the neck relaxed, the wings closed, and the arms and legs are firmly on the ground.

ARTIST AT WORK

The artist photocopied the preliminary sketch up to the final size for the painting, then erased unwanted lines using a white correction pen, adding depth to the darker areas with black colored pencil. A black fine-point fiber-tip pen was used for the fine details on the head and foreclaws. Color was added using thin acrylic washes, with opaque color laid over the top, especially in highlighted areas.

COLORS USED

ACRYLICS
ULTRAMARINE BLUE
BURNT UMBER
BLUE
PURPLE
WHITE
MAGENTA

WATERCOLOR
PURPLE

COLORED PENCIL
BLACK
BLUE

FIBER-TIP PEN
BLACK

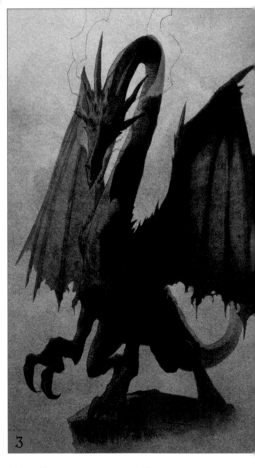

PREPARATION AND BACKGROUND

After cleaning up the pencil image on the computer, photocopy it onto watercolor paper in black only. After stretching the paper and allowing it to dry, apply pale washes of ultramarine blue acrylic to wet paper. Allow this to dry; then rewet the paper and add more layers of ultramarine to create vague cloud shapes. Repeat this process using thin washes of burnt umber acrylic, to take away the vibrancy of the blue.

DEFINING THE SHAPE

Add a flat wash of blue acrylic to the entire figure of the dragon, covering all areas of black and shadow equally. The black will be subtly lightened because the ultramarine blue is semiopaque, and areas with no color will stand out when the paint dries.

WARM COLOR COMES FORWARD

Add a thin wash of purple watercolor to the head and front claws, with the color diluted on the parts of the dragon further away from the viewer.

DISGUISING MISTAKES

Use blue colored pencil to eradicate areas of unwanted detail from the shadows. Photocopied pencil lines from shaded areas can often appear intrusive, but the colored pencil over dried acrylic washes will take away the texture of the lines.

STRENGTHEN THE FORM

Mix a midtone of body color for the skin of the dragon using white (for opacity), ultramarine blue, and burnt umber with a touch of purple. Mix the color just slightly lighter than the background color created by the washes of translucent color. Work around the line work and/or eradicate areas of confused detail.

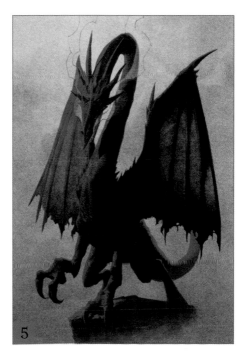

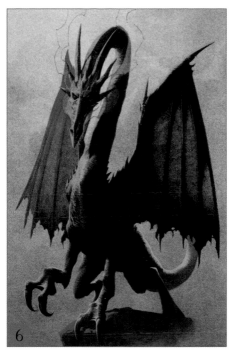

BUILDING UP THE STRUCTURE

Continue to lighten the shades, using white and ultramarine, reducing the amount of burnt umber and purple with each shade. The palest shade should be just lighter than the palest shade of the background.

ADDING HIGHLIGHTS

The mouth, smoke, and eyes are finally added using shades of purple. Add a touch of magenta for the warmest points in the center of the eyes and in the mouth, to give the illusion of a light source within the dragon itself.

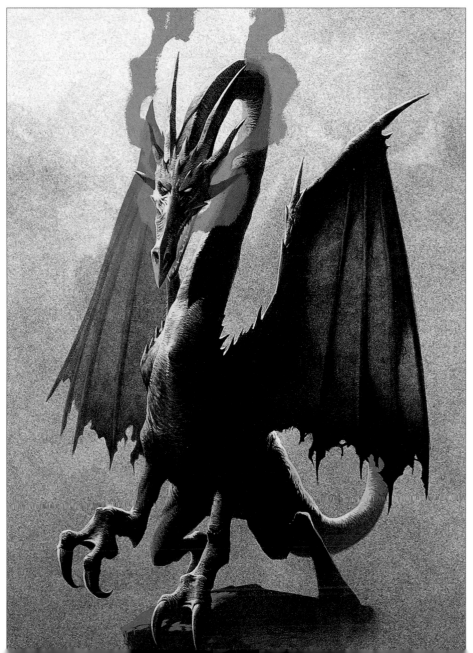

Character sketches: Vampire

Vampire stories date back thousands of years and exist in most cultures around the world. Vampire myths arrived in the west, through Eastern Europe, with traveling merchants selling their wares and telling tales of distant lands. Today, vampire stories still hold true to those old Eastern European tales of blood-drinking nocturnal beings who have returned from the dead, but many of the familiar ideas—the wearing of capes, having no reflection, and morphing into bats—are modern inventions.

This creature is completely nocturnal, exhibiting an extreme photosensitivity. It feeds principally on the blood of other warm-blooded mammals in order to alleviate a natural anemia. This diet makes the vampire very skinny. The vampiric condition can be passed to humans via its bite, giving rise to similar feeding habits among sufferers. Garlic contains an enzyme that causes an extreme reaction in both purebred vampires and contaminated humans, similar to that caused by poison ivy or nettles.

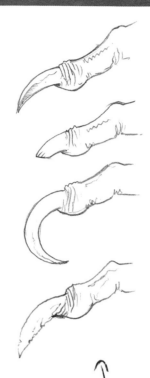

DRAWING A SKULL
The basic shape of a human skull is circular, with the lower jaw hanging off the lower front.

Following the basic shape, you can distort a creature's skull in any direction.

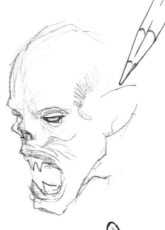

DRAWING CLAWS
There are some simple rules for drawing claws. First, remember that claws are just long, sharp finger or toe nails, with the same physiological make-up. Second, think about what you want the claws to say about your creature. These examples are fundamentally the same, but subtle differences can make big changes to the end result.

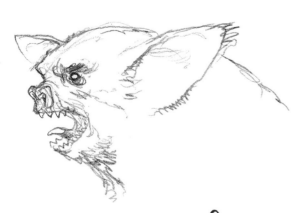

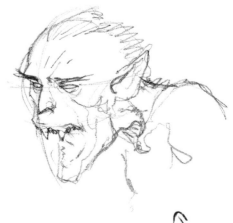

HUMAN INFLUENCE
Using a human skull as a basis for the head makes this creature less bestial.

TOO BATLIKE
This batlike head is comical (perhaps it squeals).

A MIND OF ITS OWN
After several sketches, the head begins to take a shape of its own.

FANGS

The fangs are vital for the vampire's survival. Here the gums and tongue are painted with burnt sienna—red would be too vibrant. The coldness of the skin color makes the reddish brown appear hotter by contrast. Purple is added to the burnt sienna to blend into the shadows, and yellow ochre added for the teeth. Later, to finish, white highlights are added to the teeth, gums, tongue, and eyes.

CLAWS

Omitting the thumb and giving the creature a withered little finger, like the vestigial toe on a dog's paw, makes the demon more animalistic. To make the claws appear shiny and hard, they are shaded with a mixture of burnt umber and ultramarine, leaving areas free of paint for the harsh highlights.

CREATING FORM

Explore the creature's construction. Front or side views are better at this stage because they help to build up a mental picture of the form. Begin with pale lines and use circles to represent the main joints.

REFINING

Stretching or shrinking the distance between joints changes the creature from a human prototype. Notice the shortened distance between the neck and shoulders, creating a hunched effect. The spine is short in comparison with the upper leg, and the forearms are long.

COLORING THE BEAST

Reinforce the darkest areas with a waterproof fine-line marker, then add a pale wash of yellow ochre acrylic to the areas of skin being lit by the light source. Leave the mouth and claws white. Build on the yellow with a thin mixture of raw umber, ultramarine blue, and purple. Add a pale wash of viridian green over the skin and an ultramarine blue wash down the back and arms. To add veins, use a blue water-soluble colored pencil.

CHARACTER SKETCHES: Night Elemental

The night elemental is a magical creature drawn from the dark matter of night. It can manifest itself in many forms, but favors characteristics taken from creatures associated with the night. This incarnation displays elements of cats, bats, and owls.

The night elemental can become a creature as big as 15 feet (4.5 meters) long. Its appearance varies as it takes on the characteristics of the animal form it adopts, but it can always be recognized by the starlight sparkling in its depths. It is found in the darkest of night shadows, and its appearance often coincides with the moon entering its transition phase from waning to waxing.

BAT WINGS
When drawing a creature with bat wings, note the similarity in bone structure between a human hand and that of the bat's wing.

EXAGGERATION OF REALITY
The owl heads show the contrast between a straight representation and one benefiting from the artist's exaggeration, which adds a greater sense of viciousness and evil.

EMERGING FROM CLOUD
The night elemental forms from the dark shadows of a moonlit cloud, and it begins to adopt the form of the night creatures whose qualities it embodies.

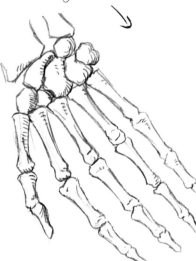

CLAW AND WING DETAIL
By exaggerating the claws, fur, and ragged edges of the bat wing, you can add a greater sense of menace.

ADDING SPARKLE
First paint the darkest areas and outlines using acrylic paints. Add a diluted acrylic wash over the whole image before going back over the details, building up the highlights. Acrylics, being opaque, can be worked from dark to light, with small highlights added with a fine brush. For extra sparkle, you could use one of the iridescent acrylics inks.

FANTASY FEATHERS
The contrast between these two feather sketches again shows the difference between a realistic and imaginative approach. The exaggeration of the feather form makes the second drawing more exciting and dramatic.

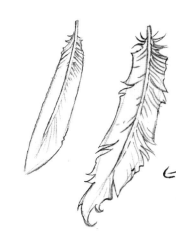

FIGURE CONSTRUCTION AND PAINTING
The pencil construction shows how the elements of the component creatures are brought together.

The darkest shades are painted in first to reinforce the form while retaining the original line work.

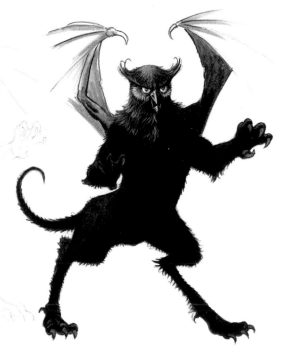

Character sketches: Werewolf

The werewolf has been used as a symbol of humankind's inner struggle with their own animalistic tendencies for centuries. This duality is what you are attempting to depict—human and beast in the same form.

It should be able to stand upright on two legs and have opposable thumbs; otherwise, it will be too animalistic and less of a monster. However, running on all fours is faster, so the arms and legs should be of similar lengths to facilitate an easy transition between being on two legs and on all four, like a primate.

Physiology fact file

Size:	Up to 6 feet (1.8 meters) tall
Weight:	140 pounds (63 kilos)
Skin:	Dappled brown and gray, sometimes tipped with white
Eyes:	Yellow or (more rarely) blue
Signs:	Savaged livestock; flattened bracken; characteristic claw prints left in soft ground

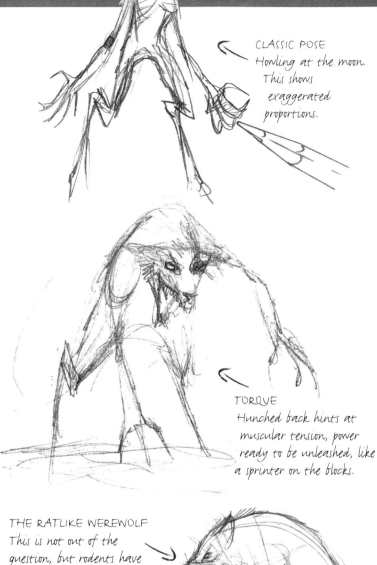

CLASSIC POSE
Howling at the moon. This shows exaggerated proportions.

TORQUE
Hunched back hints at muscular tension, power ready to be unleashed, like a sprinter on the blocks.

THE RATLIKE WEREWOLF
This is not out of the question, but rodents have different natures from wolves.

COULD THE WOLF GROW OUT OF THE HUMAN TORSO?
This would require a big tail to counterbalance the rest of its body.

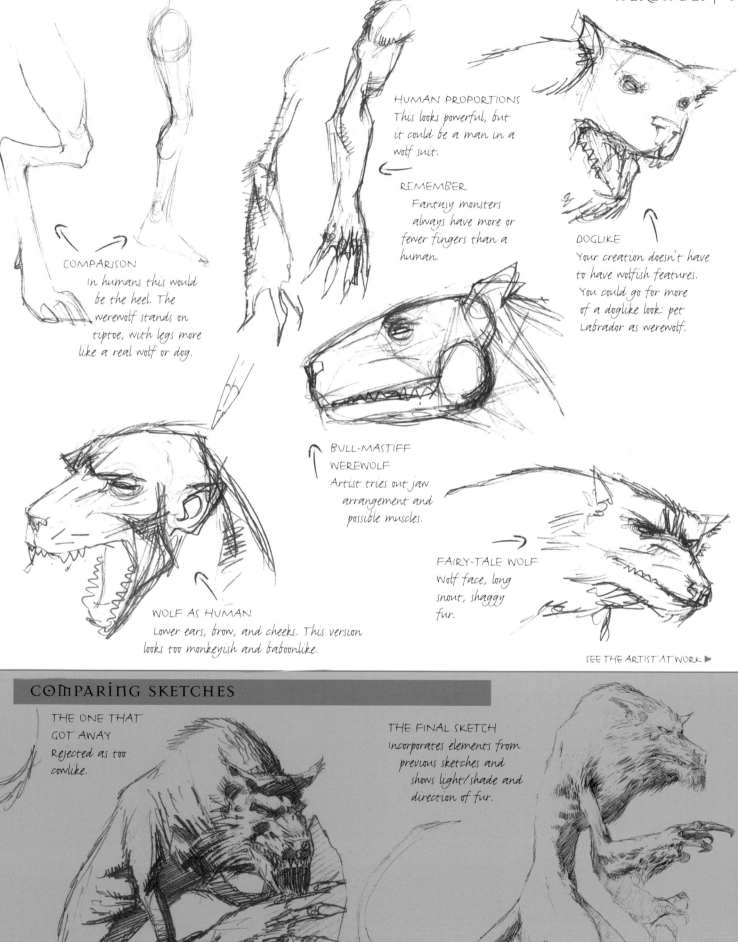

HUMAN PROPORTIONS
This looks powerful, but it could be a man in a wolf suit.

REMEMBER
Fantasy monsters always have more or fewer fingers than a human.

DOGLIKE
Your creation doesn't have to have wolfish features. You could go for more of a doglike look: pet Labrador as werewolf.

COMPARISON
In humans this would be the heel. The werewolf stands on tiptoe, with legs more like a real wolf or dog.

BULL-MASTIFF WEREWOLF
Artist tries out jaw arrangement and possible muscles.

FAIRY-TALE WOLF
Wolf face, long snout, shaggy fur.

WOLF AS HUMAN
Lower ears, brow, and cheeks. This version looks too monkeyish and baboonlike.

SEE THE ARTIST AT WORK ▶

COMPARING SKETCHES

THE ONE THAT GOT AWAY
Rejected as too cowlike.

THE FINAL SKETCH
Incorporates elements from previous sketches and shows light/shade and direction of fur.

Artist at work

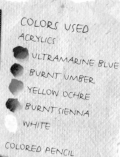

COLORS USED
ACRYLICS
 ULTRAMARINE BLUE
 BURNT UMBER
 YELLOW OCHRE
 BURNT SIENNA
 WHITE

COLORED PENCIL
 DARK BROWN
 BLACK

The artist used acrylic and colored pencil in his final illustration. The acrylic was used both in its opaque form and as a transparent medium. Preliminary sketches were drawn up (see pages 48–49) to get a feel for the beast, and then the final drawing was produced.

1

MAKING A FINAL DRAWING
Spread out all your initial sketches on your easel or work surface. Keep them out while you make your drawing, combining details from different sketches to create the finished drawing.

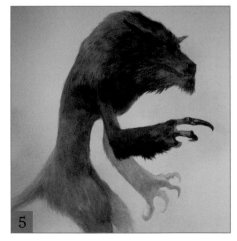

2

TRACING THE IMAGE
Increase the size of your finished drawing on a photocopier or scanner and then use masking tape to secure it to a light box. Trace the image onto watercolor paper using a dark brown waterproof pencil. Using a fine point for the eyes, claws, mouth, and nose, and a flat, worn-down point for the fur, use broad strokes to mark out areas of shadow.

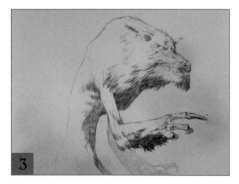

3

USING WET WASHES
Stretch the paper onto a board and allow it to dry naturally. Then, wet the paper with clean water and, working wet-on-wet to allow the colors to merge, apply thin washes of ultramarine blue and burnt umber acrylic with a large brush. Allow to dry because, if the paint is still wet, subsequent washes will blend and merge with no hard lines. Drying time can be decreased with the use of a hair dryer.

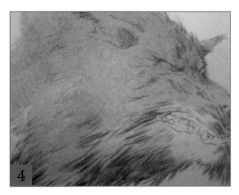

4

VARYING THE WASHES
Using the same colors but less diluted, apply washes, again with a large brush but being careful to stay close to the lines. Mix the colors on the paper to make mottled variations of blue and brown—this defines the outline of the werewolf. Be sure to feather the edges, to create the impression of fur.

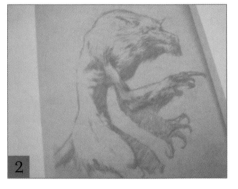

5

TONAL VALUES
After the first layer has dried, add more washes to increase the detail and modeling, building in layers to create areas of light and dark, using the initial line work as a guide. To your palette of ultramarine blue and burnt umber, now add yellow ochre to create the tonal variations in the werewolf's pelt.

6 TEXTURING THE HAIR

When the washes are dry (the paint should feel rough and abrasive to the touch), work over the top of the paint using both black and dark brown pencils. The tooth of the paper catches the pigment, helping define and give texture to the clumps of hair. Make sure to go darker in the ears and around the nose, eyes, and mouth.

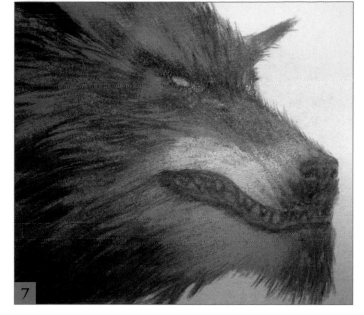

7 DEFINING THE MUZZLE

Using the dry-brush technique and opaque white acrylic paint, paint over the muzzle.

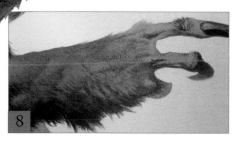

8 WORKING THE KNUCKLES

Pay particular attention to the main focal points, where you wish to lead the viewers' eyes. Increase the contrast between light and dark on harder, shinier surfaces. Here, definition is given to the knuckles with burnt umber and burnt sienna acrylics.

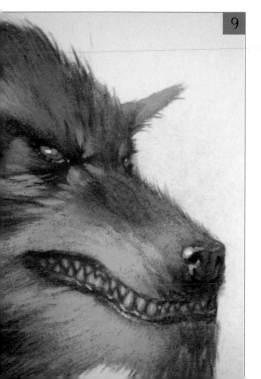

9 FINAL DETAILS

Finally, paint teeth, eyes, and nose. Give the eyes an unusual color combination to illustrate the otherworldly nature of the werewolf.

Character sketches: Demon

Demons have taken many forms over the centuries, but are traditionally seen as evil spirits or devils, though they can sometimes be good.

These evil demons flourish in densely populated but poor areas, and can usually be found infesting waste and landfill sites or amid derelict human habitation. They feed in a unique manner, draining bioelectric energy from whatever life-form happens to cross their path. Although their feeding is not fatal in itself, it often leaves their victims weak and open to attack from disease, causing psychological changes such as mood swings, torpor, and (in extreme cases) manic depression. The demon has a skeleton that grows throughout its life, developing random extrusions and bony spurs.

A TRADITIONAL VIEW
This traditional demon, taken from pre-Christian myth, is the ancient Greek god Pan, with half-human, half-goat features.

CREATING FORM
This demon has basic goat-like features—horns and a pointed head. The legs too resemble the hind legs of a goat. Note the reverse foot.

TOO GOATLIKE
A completely goatlike demon could seem too passive and non-threatening, so you need to humanize the features.

SCRIBBLE TECHNIQUE
An amorphous design like this is best sketched by the scribble technique: shapes are refined by increasing layers of pencil detail.

ILLUMINATED EYES
Add white highlights to give the eyes a glassy appearance.

FRONTAL SKETCH
This sketch shows the asymmetrical arrangement of eyes and the lack of mouthparts. Because this demon feeds on bioelectric energy rather than eating in the normal way, it has no need for a mouth. Nostril apertures reminiscent of those of the human skull provide subliminal reference.

ROUGH SKIN
The surface skin is thick and rough like that of a rhino or elephant. Colored pencil is very good for natural organic texture such as wood, fur, and, in this case, bone. For this beast, use a light French gray pencil to add the color to the demon's body

ILLUMINATED FEATURES
Glowing points on the inside of the demon's palms are where it draws out bioelectric energy. The eyes and the points on the palms of the demon's hands are painted with ultramarine blue mixed with white. Add a lighter shade of the color in the center of the pods with phthalocyanine blue, to increase the vividness.

COLORING THE BEAST
The hand-drawn image was cleaned up in Photoshop, then printed in color with a purple caste. Color was built up with washes of ultramarine blue mixed with burnt umber, gradually getting darker. An opaque acrylic mix using burnt umber, ultramarine blue, and white, with a touch of yellow ochre, was then added to areas where a sharp clean edge was required. For subsequent layers, the shades of the color were lightened with white, yellow ochre, and touches of red iron oxide to give the bone a pinkish quality. On extreme highlights, the red iron oxide is omitted.

SEA BEASTS

GETTING INSPIRATION

The ocean is full of curious creatures. A trip to the aquarium or natural history museum could be all it takes to give you an idea for a sea-based beast. Or you could try reading old stories about sea serpents.

1 The plant life of the ocean is often as colorful and lively as the animal life.

2 Sharks are one of the longest surviving predators on the planet, with evidence of their existence dating back 430 million years. Their sleek, streamlined bodies help them swim without using a lot of energy. This is important because they never really sleep, and most of them never stop swimming.

3 Look for common characteristics in real ocean dwellers and try to use some of them in your fantasy creatures.

4 Squid and octopi are among nature's strangest looking creatures. They could be straight out of the realm of fantasy.

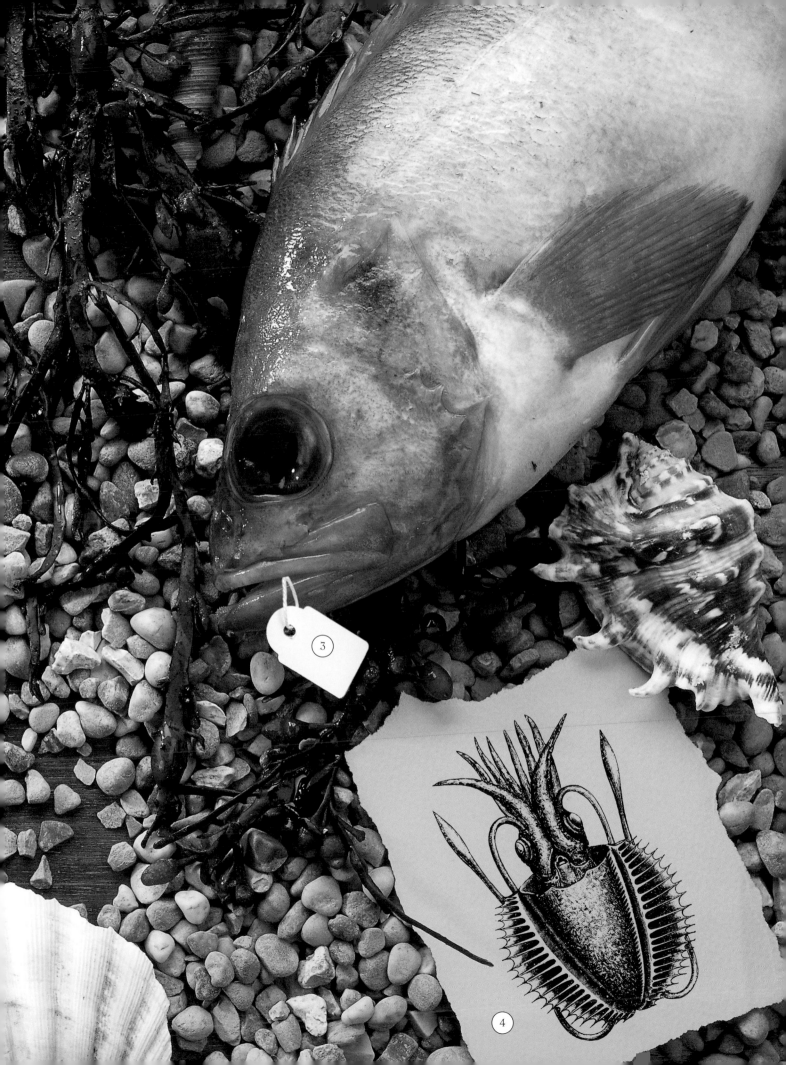

CHARACTER SKETCHES: LEVIATHAN

First mentioned in the Book of Job in the Old Testament, the leviathan is a primordial creature that has existed since pre–Old Testament times and supposedly lived long before God created Earth. Myth tells us that the reappearance of this creature heralds the end of the world.

It is so large that no human can ever see it in its entirety, and its vast size makes it capable of supporting an entire ecosystem of its own on its body. Conventional levels of detail don't apply when drawing a creature of such huge size. Think of it not so much as a creature but as a landscape, where details are rendered meaningless by distance. You could use abstract shapes that convey the sense of foreboding generated by a creature with horns as big as cliffs.

PHYSIOLOGY FACT FILE

Size:	30+ miles (48+ kilometers) long
Weight:	Unknown
Skin:	Dark blue/black
Eyes:	Dark
Signs:	Armageddon

SKETCHING SHAPES

Even though you are drawing something whose massive size disguises its true shape, it is still worthwhile sketching it just to become aware of the underlying shapes beneath the layers of coral, rock, and plant life. It is also a useful demonstration of how easily scale can be lost by drawing more of the creature.

CREATING FORM

The basic shape is created from exaggerated ellipses of different sizes.

FRONT VIEW

This front view of leviathan highlights its power and aggression, but it does sacrifice the impression of its vast size. To demonstrate this in a front view you would need to place other objects in the field of view, such as a sinking ocean liner.

SCALE

A true sense of scale can never really be appreciated in a pencil sketch, but we know roughly what size a whale is, which provides a good comparison.

TECHNIQUES FOR RANDOM DETAIL

Because the creature is so vast, you don't want to use conventional, specific levels of detail but rather take a more impressionistic approach, as in landscape painting. Here are three different ways of creating such random natural detail; they can be used on their own or combined.

The interesting variation on the impasto and dry-brush method, below, demonstrates that almost any material can be used to create interesting random patterns in conjunction with dry brushing. The colors used are unimportant, depending only on the kind of surface you want to create.

SCRIBBLE AND PAINT

1 Start with a large black marker, filling in the biggest areas of shade; then use increasingly small sizes to add lines and dots at random, almost scribbling in the shapes. Any unwanted lines can be painted over later.

2 Mix a base color, diluted enough to see the black lines, and lay it on top. For this beast, desaturated earth colors are the most suitable. Then, using a black colored pencil, add a layer of gray tone, scribbling into the darker areas.

3 Then it is a simple matter of using increasingly lighter tones of opaque color, in this case acrylic diluted to a creamy consistency, to elaborate on the shapes created by the marker.

IMPASTO AND DRY BRUSH

1 It is a good idea to use a thick black marker to draw the main areas of black on the illustration. Anything finer will be obliterated by the subsequent colors.

2 Apply an impasto base coat of acrylic mixed with a thick acrylic matte medium with a large brush or a painting knife. The paint should have a consistency slightly thinner than toothpaste.

3 Repeat the process until the desired level of surface texture is created. Slapping the brush or knife against the paper creates ridges of thick paint.

4 Using the dry-brush technique, drag paint across the surface. The paint adheres to the ridges, leaving gaps. Choose a brush size to suit the scale of the painting or the area to be covered.

5 Continue the process, mixing successively lighter tones of color and reducing the brush size until a final level of texture and detail is achieved.

PLASTIC BAG AND DRY BRUSH

1 A plastic bag wrapped around a cloth is pressed into wet paint, producing interesting shapes reminiscent of veins or seaweed.

2 Build up with successive layers of dry brushing.

3 Washes of transparent color can be overlaid to create subtle color variations. Pay attention to the tones of the colors used—lighter tones create a greater contrast in the detail.

SEE THE ARTIST AT WORK ▶

ARTIST AT WORK

The artist stretched watercolor paper onto a board and copied the shapes roughly from the sketch using a black spirit-based marker. The paper was then sealed using an acrylic matte medium. Texture was added using acrylic mixed with matte medium and drying retarder, covering the entire image. A piece of clean plastic wrap was placed over the paint and repeatedly lifted to create shapes and patterns in the paint. After drying, color was added using thin washes of transparent acrylic, with opaque color being added to lift shapes from the background patterns.

COLORS USED
ACRYLICS
LEMON YELLOW
ULTRAMARINE BLUE
BURNT UMBER
WHITE

COLORED PENCIL
BLUE-GRAY

SPIRIT-BASED MARKER
BLACK

MAKING A FINAL DRAWING
Draw the outlines and main area of shadow onto stretched watercolor paper, using a black spirit-based marker.

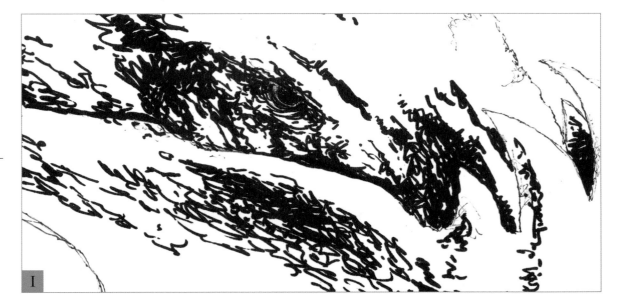

1

2

CREATING TEXTURE
After sealing the paper with matte medium and allowing it to dry, cover the entire area with a layer of acrylic color (burnt umber and ultramarine blue) mixed with matte medium and a drying retarder. Place a piece of clean plastic wrap over the paint and move the plastic wrap around to create patterns with your fingers. Lifting the plastic creates interesting textures. The drier the paint becomes, the finer the patterns.

3

DEFINING THE OUTLINE
Paint in the background using a mixture of ulramarine blue, burnt umber, and white. This will define the creature's outline.

TONAL VALUES

Following the same shapes created in step 4, pick out smaller patches with a lighter version of the same color, this time adding white and lemon yellow to the mixture. This creates the illusion of sunlight through deep water.

PAINTING DARK DETAIL

Paint in details following the pattern shapes created in step 2, using a darker version of the background color. This will create the main areas of light and texture on the creature's body.

ILLUSION OF MOVEMENT

Repeat this process, getting lighter toward the center of the patches, and making the color lighter and more yellow with each layer. Air bubbles can be added with the final shade of paint used on the body, to create a trailing effect and give the illusion of movement.

FINAL DETAILS

Paint the ring of the eye using the same colors but with less blue. Do not add a highlight because the eye is in shadow. Trails of sediment can be added to the underside with a dark blue-gray colored pencil.

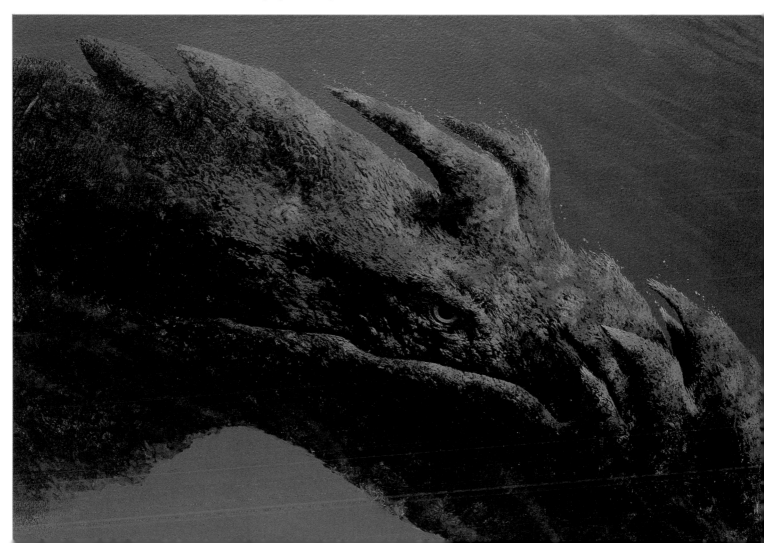

CHARACTER SKETCHES: SEA ELEMENTAL

Like the mighty ocean in which it lives, the sea elemental is powerful, fast, and easily provoked. Its size is approximately 23 feet (7 meters) from head to tail, and although its arms and head appear vaguely human, they are roughly double human size. The elemental's webbed hands and massive tail allow it to swim with amazing speed; its blue-green coloring and plantlike hair make it difficult to spot when it wishes to go undetected.

While sometimes willing to help humans lost at sea, the sea elemental is just as likely to capsize an unfortunate boat on a whim. Its wrath can be great when confronting human-made objects it considers harmful to its realm, such as commercial whalers or leaking oil tankers. By thrashing its mighty tail, the sea elemental can usually generate waves large enough to scuttle any vessel, and its sharp claws and amazing strength enable it to punch a hole in most ships.

This sea elemental has been given a very mysterious and alien look by incorporating elements from both sea plants and sea creatures. However, by adding humanlike arms and a vaguely human head, we make sure the viewer knows it is intelligent and probably able to communicate.

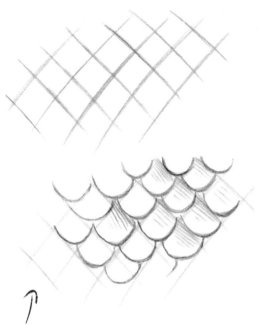

DRAWING SCALES
Scales can be difficult to draw. This two-step process helps get them right every time.

CREATING FORM
The head can be made from simple shapes. It is flatter than a human head and needs a lot of space for the large eyes and mouth. Starting with a rough trapezoid with the bottom larger than the top, as shown here, can help you get the right shape.

ADDING DETAIL
The sea elemental blends into his surroundings using his plantlike hair.

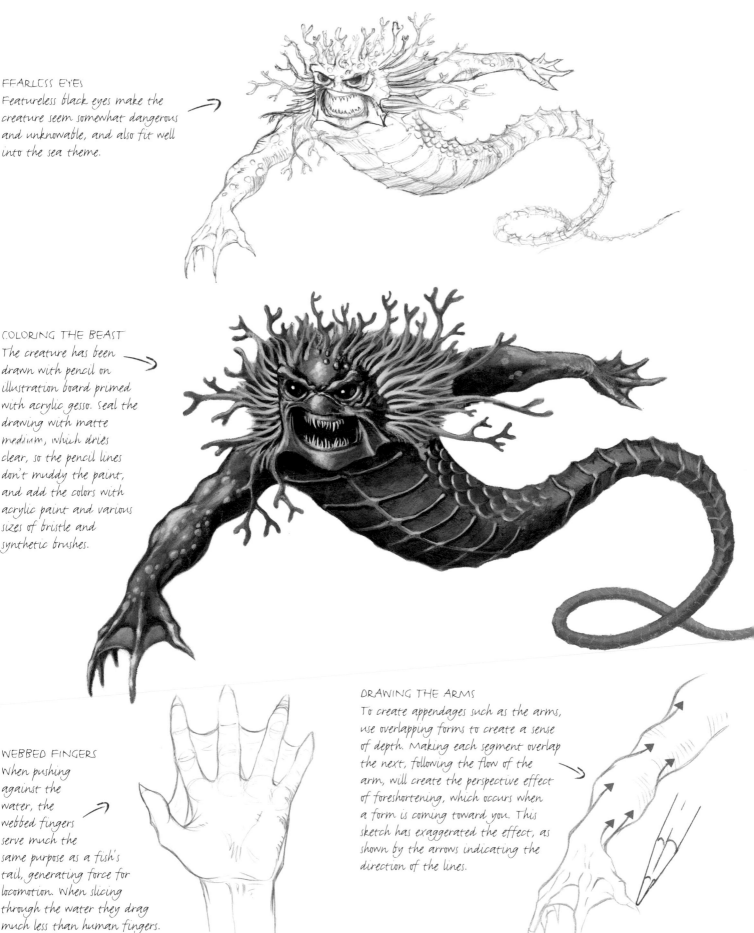

FEARLESS EYES
Featureless black eyes make the creature seem somewhat dangerous and unknowable, and also fit well into the sea theme.

COLORING THE BEAST
The creature has been drawn with pencil on illustration board primed with acrylic gesso. Seal the drawing with matte medium, which dries clear, so the pencil lines don't muddy the paint, and add the colors with acrylic paint and various sizes of bristle and synthetic brushes.

WEBBED FINGERS
When pushing against the water, the webbed fingers serve much the same purpose as a fish's tail, generating force for locomotion. When slicing through the water they drag much less than human fingers.

DRAWING THE ARMS
To create appendages such as the arms, use overlapping forms to create a sense of depth. Making each segment overlap the next, following the flow of the arm, will create the perspective effect of foreshortening, which occurs when a form is coming toward you. This sketch has exaggerated the effect, as shown by the arrows indicating the direction of the lines.

CHARACTER SKETCHES: SEA DRAGON

This dragon is the classic sea serpent much dreaded by sailors. Fear of these creatures was at its height in the fifteenth century when Western explorers were trying to reach the East. At the time, many people believed the world was flat and ships would sail until they fell off the end of the Earth. Maps with uncharted waters were marked "here be dragons."

The sea dragon is related to the swamp dragon but can survive in fresh and saltwater environments and to greater depths. Like its most famous relative, the Loch Ness monster, it is rarely seen above water.

The sea dragon is a fiercely territorial creature and has been known to attack submarines at depth. It has a voracious appetite and feeds on large aquatic creatures.

OPEN OR CLOSED
With large or long teeth, leave bigger gaps between them in order for the mouth to close fully, except when a character has lips (like an ape or human) that conceal the teeth inside the mouth parts.

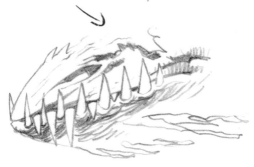

LIGHTING A TRANSPARENT OBJECT
A conventional tooth is opaque, darkening toward the base.

A translucent or transparent tooth, such as the sea dragon might have, acts more like a lens or the crystal ball shown below.

An overhead light source inverts light within the crystal ball, so that the darker area is closer to the light. There is still a highlight on the outside because the object is shiny, and even though transparent, it casts a shadow.

PRODUCING A GLOW

This technique works for any luminescent part of a creature, whether it be eyes, or in this case the antennae of the sea dragon. It is easiest to do with opaque color such as acrylic or gouache. With transparent paints like watercolors or inks, the highlight area has to be reserved by painting around it.

1 Fill the shape with the desired color, using a tone just slightly lighter than the background, although not necessarily of the same color family.

2 Use successively lighter shades of color, making the areas covered smaller each time. The brightest part should be the origin of the light source. Adding a second color other than white can add extra interest, but the color should become lighter and warmer as it comes closer to the brightest point.

3 Adding a white highlight on another part of the shape can give the impression of the light being contained within a hard or shiny shell.

DIRECTION OF TRAVEL

The direction of water acting on the sea dragon is opposite to the direction traveling. This sense of movement is increased by making the leafy tendrils on the fins recede behind it, as though trailing in the water.

THE ILLUSION OF MOVEMENT

Create a sense of movement that acknowledges the structure and behavior of the creature. The sea dragon has no limbs, and its insubstantial winglike fins could not possibly move such a large creature on their own. Giving it an undulating shape suggests that it moves through the water rather like an eel.

WATER

PAINTING THE CREATURE

The dragon was painted in acrylic, using layers of gray washes mixed from ultramarine, burnt umber, and purple. Grays mixed from other colors, known as "colored grays," are much more interesting and lively than black-and-white mixtures. Extra layers of modeling and detail were added with a silver-gray colored pencil, and a blue pencil was used on the large sail fins. In the final stages, opaque white acrylic with a touch of purple was brought in to neaten edges and add highlights.

CHARACTER SKETCHES: KRAKEN

The kraken is a fearsome sea monster, originating in stories from Norway in the twelfth century. According to legend, this creature, often described as being the size of a small island, could wrap its arms around the hull of a ship and capsize it.

The kraken of these stories could be what we now know as the giant squid. Giant squids have not been seen that often, and little is known of their habits, but their existence is accepted. They are not the size of a small island, but they are large enough to wrestle with a sperm whale and have been known to attack ships.

These krakens tend to exist in colder seas; they use the hornlike shell on their heads to break free from the ice that traps them. Their arms are covered in suckers and sharp rotating hooks.

CREATING FORM
The kraken is made of several shapes: the mantle, the cylindrical body, the shell, the head, and its many tentacles. Loose lines were used to show the creature's sinuous nature.

EYES FRONT
The kraken's eyes are similarly positioned to those of an octopus. The horn on its head was inspired by the shells of the long-extinct belemnite.

MOVEMENT
The kraken moves by jetting water through a siphon underneath its body and steering with the large fins that protrude from its mantle, just like a squid.

COLORING THE BEAST
The hooks on the kraken's arms are like those of the colossal squid, the biggest squid in the ocean. This beast was created in Photoshop. After finishing the design, a loose sketch was drawn and the final painting made over it. Draw the suction cups individually.

FEEDING TIME
The five pairs of arms surround the kraken's strong beak. The arms can trap big prey and draw it into the creature's large mouth.

SQUIDLIKE FEATURES
Like the giant squid, the kraken has ten arms, two of which are thinner and longer. These arms are used to catch food and take it to the mouth.

CHARACTER SKETCHES: MER-CREATURE

The mer-creature is a hybrid of myths and folklore, combining the myths of mermaids and other sea creatures (such as selkies and the sirens of ancient Greek myth).

The mermaid was regarded as a natural creature rather than one of supernatural origins and was supposed to lure sailors to their deaths on shallow rocks by the power of its singing. Belief in its existence continued until relatively recently. Indeed, so powerful has been the belief in mer-creatures

that fishing communities in southwest England claimed to have persons of mermaid or merman descent living among them, people with special powers and an affinity with the sea.

A SILVERY SHEEN

Here's a simple technique to create the silvery sharkskin effect on the mer-creature.

1 Transparent waterproof acrylic ink is used for the base colors. Once these and skin patterns have been applied, allow them to dry thoroughly and then color the light areas with a pastel pencil. In this case white is used, although any pale color would be suitable.

2 The pastel pencil will appear grainy, so rub it with a clean finger to smooth the new color into the grain of the paper.

MARINE MOTION
Marine mammals, such as dolphins, whales, and seals, move through the water using a vertical motion. Giving the mer-creature a mammalian tail makes it less fishlike.

CREATING FORM
A long sinewy shape suggests a creature that is at home in water.

Fish move through the water using a sideways motion.

EYELIDS
Fish don't have eyelids, but the mer-creature is a mammal-fish hybrid, so it could be given more human eyes. It depends on which direction you want the design to go; eyelids might swing it too far in the mammalian direction.

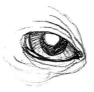

GILLS
Large gills line the creature's throat and hide any musculature on the neck.

CAMOUFLAGE
Thin fleshy membranes on the creature's head mimic seaweed and act as camouflage.

FACE DEVELOPMENT
Large fish eyes and platelike shapes on the face are similar to those of fish.

COLORING THE BEAST
The entire paper was soaked in water, and blue and green inks were applied randomly and encouraged to merge. The paper was then left flat to dry. The figure was then colored with green and purple inks, with some colors allowed to blend in places to give soft edges and others applied over dry ink to create hard edges. To give the skin an iridescent sheen, a white pastel pencil was used over the dry ink and blended in places with a finger. The eye was painted in opaque green and yellow acrylics, with a final highlight of white.

CHARACTER SKETCHES: GIANT VIPERFISH

The viperfish is a large, fast, and powerful predator. This solitary beast usually hunts in the depths of the oceans, but sometimes ventures closer to shore if food is short.

The viperfish can grow up to 13 feet (4 meters) long, weighing some 44 pounds (20 kilos), but despite its size it is rarely seen, striking unexpectedly and leaving no signs of either itself or its victim.

When choosing coloring for your rendering, stick to cool colors such as blues and greens. Also remember, things that are farther away appear less vivid than closer objects. Use this effect to give the illusion of length to your viperfish.

THE DEFINING FEATURE
The viperfish claims its name from the large teeth that protrude from its jaws. There are two large upper and two large lower teeth, which somewhat resemble the fangs of a viper.

EYE DETAIL
The giant viperfish has large eyes, allowing it to see in the dark murky waters of the ocean.

CREATING FORM
When drawing your viperfish use lots of s-shaped curves and overlap shapes to give your design depth.

ADDING DETAIL
Large fins help the giant viperfish to swim at speeds exceeding 60 miles (97 kilometers) per hour.

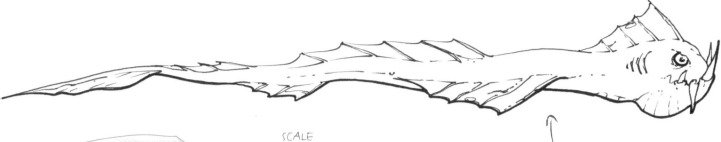

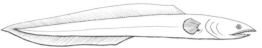

SCALE
The giant viperfish grows up to 13 feet (4 meters) long, roughly three times the length of an average conger eel, which is about 4½ feet (1.5 meters).

BUILDING UP COLOR
This beast was hand drawn and colored digitally, using multiple layers in the Photoshop program. Starting with two basic colors, green and red, you can introduce subtle variations. For example, on the green skin use hues of blue and purple within the shadows and yellow in the highlights. These color shifts are very subtle but give a more realistic impression.

DESERT BEASTS

GETTING INSPIRATION

On the surface the desert may seem dry and dull, but dig a little and you'll find a wealth of creatures and stories to inspire you. Think about what could survive and evolve in such a climate.

1 Camels, known as "ships of the desert," have evolved physiologically to cope with both heat and dehydration.

2 When thinking about your fantasy beasts, use the physiology of real creatures to get you started.

3 Practice drawing skulls and bones at your local natural history museum, and you'll soon get to know the basic shapes.

4 The Moloch lizard is a real animal, but it looks supernatural. It is covered with thornlike spines, giving rise to the alternative name, "thorny devil."

5 Scorpions are highly dangerous creatures, but their segmented bodies make them fun to draw.

CHARACTER SKETCHES: MINOTAUR

The minotaur, like many creatures of fantasy, has its roots in Greek mythology. This monster was the offspring of Queen Pasiphae, wife of King Minos of Crete, and a beautiful white bull—with whom the gods forced her to become infatuated, as a punishment for her husband's refusal to sacrifice it to Poseidon. King Minos kept the minotaur trapped within a labyrinth, feeding him upon human sacrifices until he was eventually slain by the hero Theseus.

Although this minotaur is a human–bovine hybrid, it is less human than the original mythical beast. The humanoid appearance comes from the presence of ancient protohuman genes, perhaps Neanderthal or even earlier. These genes are recessive, so minotaurs are a doomed species, and over generations the humanoid characteristics disappeared as the dominant bovine traits asserted themselves.

PHYSIOLOGY FACT FILE

Size:	Up to 8 feet (2.4 meters) tall
Weight:	266 pounds (120.5 kilos)
Skin:	Golden brown hide with dense bristly fur. Fur tone varies from black to dark blond, depending on familial characteristics
Eyes:	Generally hazel to dark brown
Signs:	Scratches on tree trunks and wooden posts where horns have been used to mark territory

CREATING FORM
The hunched pose hints at a heavy, lumbering gait, like a bull.

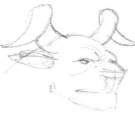

COMPARING SKETCHES
Although the bull features are all-important, there are as many types of horns as there are cattle, so experiment. The shape of the horns can decide the character as much as anything else.

DRAWING HANDS
When drawing hands, look at your own hand as a starting point.

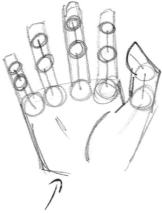

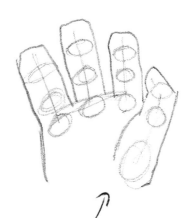

This basic structure can be altered to suit your design.

Big thick fingers make a character seem strong, but there is no room for the smallest finger.

CREATING HAND DETAIL

The use of wrinkles can indicate elasticity, suppleness, and flexibility. Fewer wrinkles indicate more flexibility; the skin is very supple, like frog or newt skin. It is advisable to use photographic references for skin textures and details, though the lines in your own hands and face can be used as a starting point.

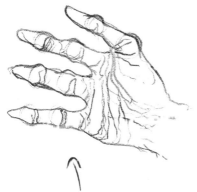

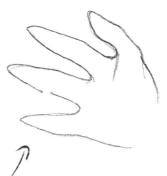

The same hand, with added wrinkles, makes the skin simply look puffy and bloated because the proportions are still the same. Fat and chunky shapes mean there is still a lot of moisture in the body.

A hand without surface detail, like any part of a beast, can look like it's made of rubber.

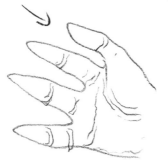

When a creature ages, it can lose body moisture and fatty tissue, especially around the joints. Major joints should be exaggerated in old, dry, or starving creatures. Wrinkles should be deepened; lines always show up stronger on dry skin.

SEE THE ARTIST AT WORK ▶

LIGHTING

Before you start a drawing, establish the light direction. Practice by drawing simple shapes.

Light low and to the front

Light low and to the rear

Light low and directly under shape

These shaded spheres show how a light source seemingly in the same position can be made to assume a different point in space by the addition of a shadow.

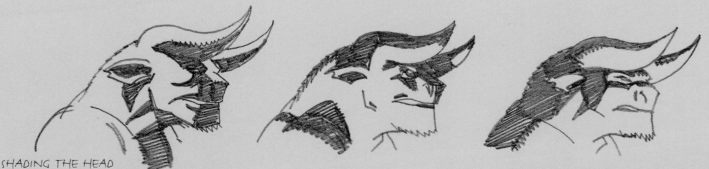

SHADING THE HEAD

The same principles apply when drawing a complex shape, such as the minotaur's head. Here the shadows have been exaggerated to illustrate the principle, but a basic rule of thumb is that the stronger the light–dark contrast, the brighter the light source.

ARTIST AT WORK

The artist drew the underlying line work on a light box from preliminary sketches, in black colored pencil and black fine-point waterproof fiber-tip pen. Color was added using thin transparent washes of acrylic and colored pencil, with opaque color used only for highlights and cleaning up edges.

COLORS USED
ACRYLICS
 YELLOW OCHRE
 PURPLE
 ULTRAMARINE BLUE
COLORED PENCIL
 BLACK
FIBER-TIP PEN
 BLACK

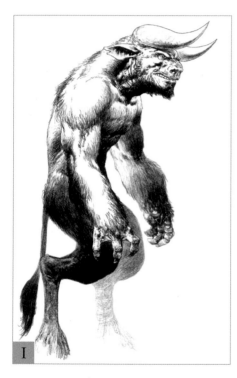

ADD A WARM UNDERLAYER

Dry the background with a hair dryer; then paint a wash of yellow ochre over the entire figure.

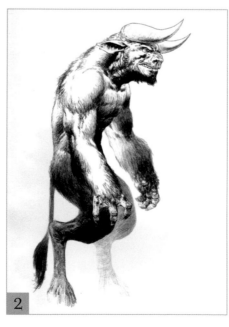

PREPARATION

Enlarge the pencil sketch on a photocopier; then trace it onto watercolor paper (using a light box) with a black fine-point waterproof pen. The ink line is used only as far as the waist and for the arm in the foreground. Choose black colored pencil for the area farther away, and the legs, because a more vague and indistinct foundation is required for these parts of the drawing.

BACKGROUND

After stretching the paper onto a board and allowing it to dry, rewet the paper with loose strokes of diluted yellow-ochre acrylic applied as a dusty background.

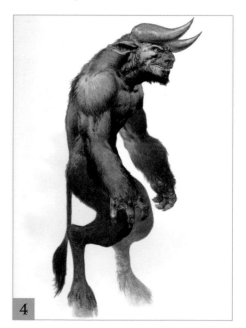

CREATING FUR EFFECT

Add subsequent layers of translucent wash. Use different mixtures of yellow ochre and purple, darkening the shaded areas and working in the effect of fur with loose strokes.

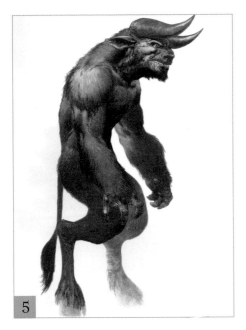

5

BUILDING UP COLOR
Increase the strength of the color until you achieve the desired effect.

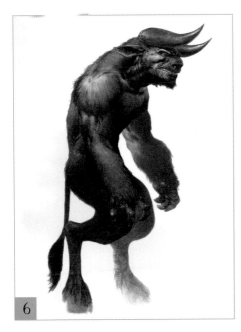

6

HIGHLIGHT THE SKIN
Pick out areas, especially bare skin, with diluted ultramarine blue. This gives them a greenish cast and separates them from the furred areas.

FINAL DETAILS
Pick out highlights on the hands and head. The addition of diluted ultramarine blue, with a small brush, to the topmost parts of the face and horns gives a reflective quality, hinting at hard or shiny surfaces.

CHARACTER SKETCHES: SPHINX

In Greek mythology the sphinx, a creature with the head of a woman and the body of a lion, was the winged monster of Thebes. She was a curse sent by the gods, and allowed no one either to leave or to enter the city. In Egypt there are numerous sphinxes, usually with human heads but sometimes with those of other animals. The Great Sphinx of Giza is the most famous image of this creature. This colossal statue is a national symbol of Egypt and one of the world's best-known ancient monuments.

The sphinx assumes the role of guardian. Although the Egyptian civilization is long since vanished, the sphinx may remain in remote desert areas, guarding the long-lost treasures of the pharaohs' tombs, which have been hidden beneath the desert sand for thousands of years.

Their huge muscular lion's body and vast wings make them powerful creatures that can travel over land or through the air at lightning speeds. Sphinxes are very intelligent and often ask riddles. They are proud and arrogant and definitely not to be toyed with.

EGYPTIAN INFLUENCE
The sphinx traditionally wears an Egyptian headdress.

ADDING DETAIL
For the feathers, start with oval shapes and then add diagonal lines for detail. The feathers overlap each other, as shown here.

INFLUENCE AND INSPIRATION
The sphinx has the body of a lion, the wings of an eagle, and the head of a human. Reference the component animals to create the form.

DRAWING FUR
For the lion's coat, draw lines moving in the same general direction but with some variation in length and angle to give a less uniform effect.

CREATING FORM
Begin creating your sphinx by drawing a rough outline, gradually building up details.

DRAWING THE EYES
Egyptian-style eye makeup: solid black lines surround the oval eye shape to give that distinctive look.

COLORING THE BEAST
The sphinx has been colored in Photoshop. Fill in the different areas with block colors; then build up the form by adding shadows and highlights. Varying the brush strokes will help define the different textures of fur, feathers, and metal.

DRAWING THE PAW
Notice how the two middle claws are set slightly forward, like those of a real lion.

WALK LIKE A LION
The sphinx walks with the wings folded down. When a lion walks, the two legs on one side of its body move together, while those on the other side move apart.

CHARACTER SKETCHES: DESERT DRAGON

The desert dragon is similar in look to the komodo lizard, the largest lizard on the planet. Rather than scales, this dragon has dense wrinkled skin similar to that of a rhino or elephant.

Although this dragon is winged, it is really too heavy for sustained flight. It tends to use its wings to swoop down on its prey from large rocky cliffs and canyons. It inhabits arid desert canyons and mountainous regions; its main prey is sheep, goats, and cattle.

The desert dragon is a fire-breather, but it does so only on rare occasions—for defense, or during the nights of the mating season, when the female dragons are drawn to the most impressive displays.

HEADS
Dragon heads can be formed from a loose triangle, or a cone if seen in perspective.

The purpose of the long, pointed face is to make dragons more aerodynamic. The same principle applies to water-based dragons.

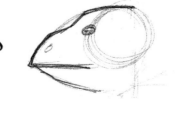

The skull follows the same drawing principles as any other creature. Use circles to show where the brain casing is situated. For the jawbone, as with other features of dragons, look to dinosaurs for inspiration.

A short, blunt head will seldom work because it tends to make a dragon appear stupid, docile, heavy, or unthreatening—rather tortoiselike, no matter how many horns and teeth you add.

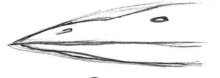

A long, pointed head makes a dragon look sleek, cunning, sinewy, and more threatening.

FLAME SHAPES

Conveying the ferocity and power of the flames isn't simply about color—the shapes are also important. Long, stretched shapes indicate a far more ferocious flame than rounder, curlier shapes.

MAKING FIRE

If you want to show your dragon breathing fire, here are a few useful techniques.

WET-ON-WET
Colors are layered, to create the shapes. Start with the reds (the midtones), and then overlay lemon yellow, leaving the point of origin of the flames (a dragon's mouth, for instance) as the palest tone. Finally, pick out darker areas in purple. Acrylics or waterproof inks are better than watercolors, because with watercolors you would have to start with the lightest colors—the yellows.

IMPASTO
Here thick paint is used in an impasto method, relying on the intermingling of two or more colors to create the effect. You could use acrylic, gouache, or even oil paint, but the color must remain wet all the time, so with acrylic or gouache you will have to work quickly.

DRAGON CONSTRUCTION
To construct this dragon, follow the basic principles on page 40.

PEN AND INK TECHNIQUE

Pen and ink is an excellent medium for drawing dragons because it allows for a high degree of detail and variation of line. In this case a fine-point sepia pen is used, which creates a less harsh effect than black. To build up form and texture, use more marks for the shaded areas, such as the shadows created by the surface texture, and fewer—or none at all—for the brighter areas.

1 Draw the creases and folds with fine-point pens. The line widths can also be varied by the angle at which you hold the pen. The more the pen is angled, the finer the lines. Adding small dots and lines gives the impression that the skin is heavily textured.

2 For midrange tones, use a medium-point pen, but instead of using a uniform angle of lines throughout, try to imagine the shapes, angling the lines to follow the curves. At this stage it is best not to overlap lines.

3 In the darker areas, again follow the curves of the surfaces but with the lines at a right angle to those in step 2. Lines can be placed closer together in the darkest areas.

FINISHED SKETCH
This illustration was finished in pen and ink but started in pencil. Here, soft pencil has been used for medium-toned shading and to establish the main shapes.

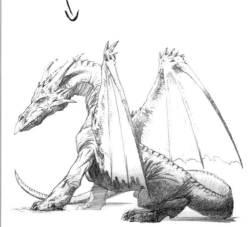

PAINTING THE DRAGON
The dragon was colored using layers of thin acrylic washes worked from light to dark. The initial colors were browns mixed from yellow ochre and purple. The purple was gradually increased to build up the darker shades. A thin band of ultramarine was added on the spine, and opaque white acrylic was used in the final stages to neaten edges and add highlights.

CHARACTER SKETCHES: SANDWALKER

It is on the darkest, coldest nights that Bedouin tribes of the desert draw closer to the campfire and talk in whispers of the strange and fearsome creatures that stalk the dunes. Most feared among these is the sandwalker, a monster of terrifying nightmares.

From time to time, these nomadic desert people will wake to find that their carefully tethered camels have disappeared in the night. Only the faint impression of crablike tracks provides irrefutable evidence that their beasts of burden have fallen prey to the most feared of desert predators. Rumor tells of the way in which these creatures bury themselves beneath the dunes, moving silently through the sand and then emerging from the desert floor to fall upon their victims with a frenzied attack of venomous tail, rending claw, and snapping beak.

For fantastical beasts such as this, it is advisable to use real-world reference material. Drawing on images of creatures that inhabit a desert environment, this beast combines elements of crab, scorpion, and predatory birds.

REAL-LIFE INFLUENCES
Based on the tail of a scorpion, this sketch shows the lethal spike with which the sandwalker pins its prey as it injects paralyzing venom.

ROUGH CHARACTER
A quickly executed drawing in broad-nibbed markers establishes the fundamental characteristics of the monster, without worrying too much about producing a polished image. Many of these quick illustrations will be created to develop the monster's form.

DRAWING THE LEGS
Simple, geometric shapes are used to form the monster's legs.

LEG TEXTURE
Using a pencil, and working from the previously established geometric armature, the artist explores the textures of the monster's armored legs.

CLAW DETAIL
Many of these quick sketches may be produced as the artist defines the look of the elements that combine to make up the monster.

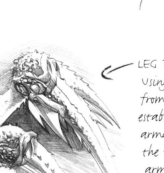

BUILDING UP
Rendering is used to delineate the forms and textures of the creature's leg.

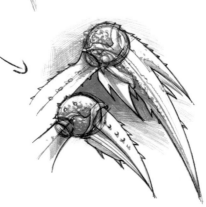

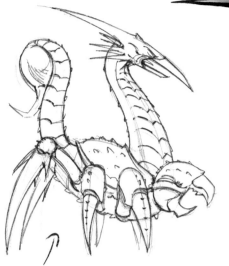

CREATING FORM
Basic geometry is used to explore the way in which the creature would stand and walk. Altering the balance of masses in a drawing such as this can drastically change the final look of the beast.

COLORING THE BEAST
This beast was drawn in pencil and enhanced by overdrawing with a fine brush and waterproof black India ink. The final result was a clean black-and-white rendering of the monster. This was then scanned into the computer and colored using Photoshop.

DRAWING THE HEAD
A pencil illustration of the forms that make up the monster's head has been scanned into the computer and digitally enhanced. This is another step in refining the creature's final appearance.

REFINING THE WORK
Working from a marker visual, the artist has created a refined pencil illustration of the monster, which he has subsequently enhanced with India ink applied with a fine sable brush.

CHARACTER SKETCHES: DESERT ELEMENTAL

The desert elemental is made up entirely of sand, which it can make harder or softer at will and turn into any shape it wishes. Most often, the desert elemental appears as nothing more than a tract of desert sand, indistinguishable from its surroundings. When angered or disturbed, it will rise up from the desert floor in humanoid form.

The elemental's motion is like a wave on the ocean, sliding from one area to another. This process can be terrifyingly fast, allowing it to travel at more than 60 mph (100 kph) if needed. However, because of his sandy makeup, the desert elemental can only exist in the desert.

His internal temperature is quite hot—175–195°F (80–90°C). This gives him ominous glowing eyes and means sure death for any living beings he might ingest, either by putting them in his mouth or by simply enveloping them in sand. If any human caravan is unfortunate enough to stumble on this creature, it will be swallowed up in his massive sand swell, never to be seen again. His sense of touch is especially acute, because each grain of sand that makes up his body acts like a nerve ending.

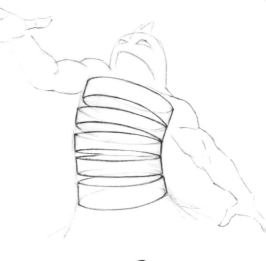

CREATING FORM
A curved, elongated body can be created from a series of short cylinders, as pictured here. By putting them together at different angles, the feeling of a very solid yet curved body can be achieved.

RENDERING SAND

There are several ways to achieve a soft, sandy texture. Below are four examples.

1 Use a toothbrush dipped in paint to spatter fine dots on the painting.

2 Use a large paintbrush dipped in diluted paint to spatter larger, more random dots.

3 Tap the tips of a stiff bristle brush on the paper to create a soft, textured look.

4 Use a dry brush with a bit of undiluted paint to create broken strokes of color, by brushing softly over the surface.

SCALE
To show that your creature is large, place it next to a known object, such as a tree or house, to indicate scale. Compare these sketches. In the first the beast could be any size, but in the second picture it is clear that it's a marauding giant.

BUILDING UP

When the elemental appears in humanoid form it can rise up to hundreds of yards (meters) high, using as much of the surrounding sand as it wishes to create a temporary body. This piece is painted with acrylics on illustration board, starting with a detailed gray-scale painting on the board.

PAINTING THE BEAST

Thin washes of acrylic were layered over the gray scale to build up color, and final details were achieved with more opaque paints. Including the detail of sand falling from your creature gives the impression of a being made from a loose conglomeration of material. The elemental's internal temperature remains very hot at all times, which gives him red, glowing eyes.

Swamp Beasts
Getting Inspiration

Swamps are the hot and sticky breeding grounds of all sorts of creatures. Visit a natural history musem or the hothouse at the local botanical gardens to get an idea of the inhabitants of this environment.

1 Amphibians spend part of their time underwater, breathing with gills, and the remainder on land, breathing with lungs. They are cold-blooded, so their body temperature depends on the temperature of their environment.

2 Snakes are scaly, cold-blooded, egg-laying reptiles. They provide a good resource for creeping, slithering non-limbed creatures.

3 Gharials differ from the crocodiles and alligators by their long, narrow snout—ideal equipment for seizing fish and frogs underwater. Their hind limbs are paddlelike, and these creatures rarely leave the water, except to nest. Gharials have great natural features to suit their environment.

4 Zoos and aquariums are excellent places to check out real features, such as claws, close up.

CHARACTER SKETCHES: GIANT WORM

The giant worm, like its smaller cousins, feeds on dead and decomposing matter. Perfectly at home in polluted areas, its existence is seen as a prime indicator of an unhealthy environment. A giant worm's life span is measured in geological terms, with specimens predating humans. Traces of giant worms can always be found around mass graves, especially in the fossil record, signifying major extinction events like that of the dinosaurs.

This mutant worm is related genetically to the caterpillar, sharing much of its anatomy, including spinnerets. However, the giant worm doesn't use them to weave a cocoon to enter the chrysalis stage for metamorphosis into a butterfly or moth. The giant worm uses its spinnerets to weave a cocoon for hibernation and to imprison and preserve its prey.

PHYSIOLOGY FACT FILE

Size:	38 feet (11.6 meters) long
Weight:	Up to 900 pounds (408 kilos)
Skin:	Pale pink and luminous with green extremities
Eyes:	Black
Signs:	Crushed and flattened undergrowth; devastation

INSPIRATION SKETCH COMPARISONS

A real earthworm can give you ideas for movement, but because worms are visually dull, it's best to draw reference from other invertebrates such as leeches and caterpillars.

The moth caterpillar is more interesting, and here the rearing pose, with the caterpillar reaching up for hanging leaves, has provided an important reference.

FEEDING

The giant worm has hinged mouth parts that surround an open gullet. The appendages operate more like sharp claws than teeth, scooping decaying matter into its mouth for consumption.

CREATING FORM

Always construct a creature like this with a series of loose circles. Think of them as spheres, and use them to help convey the foreshortening effect, overlapping them and making them larger at the front of the creature.

COLOR SCHEMES

When deciding on a color scheme, consider the purpose served by the creature's color. In nature, the color generally serves one of two purposes—camouflage or warning. However, the giant worm is not defenseless, unlike real worms and caterpillars, so there is more leeway, but still the color should say something about the creature's habits and environment. The color scheme for the painting overleaf was chosen to echo the themes of sickness and decay.

CAMOUFLAGE
This patterning would disguise a creature within its environment, hiding it from potential predators.

WARNING
This patterning should dissuade a predator from attacking. In these cases the creature is either highly poisonous or pretending to be.

BRUISING
The bruise color scheme, used in the final painting, conveys a creature that dwells in a gloomy environment.

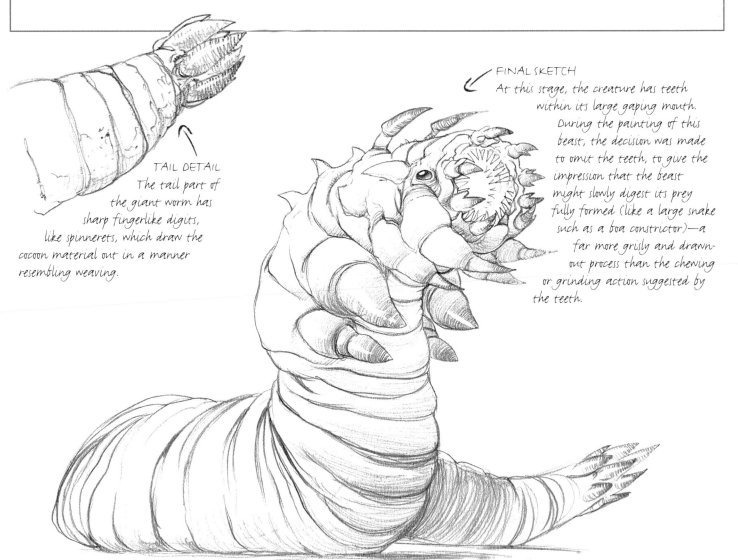

TAIL DETAIL
The tail part of the giant worm has sharp fingerlike digits, like spinnerets, which draw the cocoon material out in a manner resembling weaving.

FINAL SKETCH
At this stage, the creature has teeth within its large gaping mouth. During the painting of this beast, the decision was made to omit the teeth, to give the impression that the beast might slowly digest its prey fully formed (like a large snake such as a boa constrictor)—a far more grisly and drawn-out process than the chewing or grinding action suggested by the teeth.

SEE THE ARTIST AT WORK ▶

ARTIST AT WORK

The artist traced the image from an enlarged sketch onto parchment textured paper using a light box with a warm gray fine-point spirit-based marker. Color was added using transparent acrylic washes with green ink on the extremities. White highlights were added using opaque acrylic.

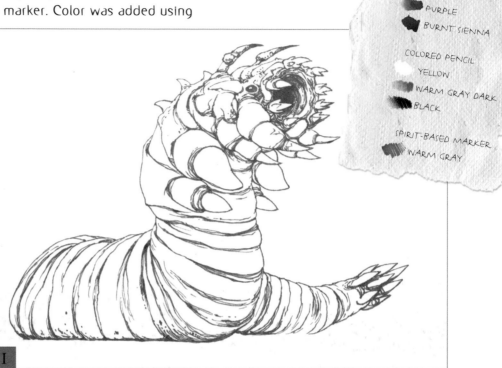

COLORS USED
ACRYLICS
WHITE
YELLOW OCHRE
PURPLE
ULTRAMARINE BLUE
BURNT UMBER

INK
GREEN
PURPLE
BURNT SIENNA

COLORED PENCIL
YELLOW
WARM GRAY DARK
BLACK

SPIRIT-BASED MARKER
WARM GRAY

FINISHING THE DRAWING
Trace the outlines and main areas of shadow onto parchment textured paper, using a warm gray fine-point spirit-based marker.

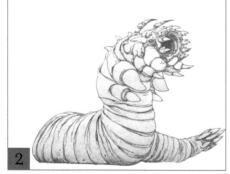

STIPPLE THE BODY
After stretching the paper and allowing it to dry, fill in the entire shape of the creature using a thin mixture of yellow ochre and purple acrylic to create a pale flesh tone. Use a large brush with a fine point (which will hold a large quantity of paint). With only the tip, stipple the color with short dabbing strokes, leaving small areas free of paint.

BLENDING COLOR
Color the extremities, tail, and mouth parts. First wet the area to be colored with clean water; then apply diluted purple ink, starting from the darkest part of the shape and blending out into the wet shape until no color is applied.

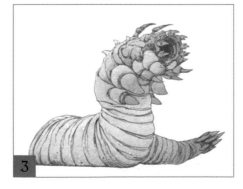

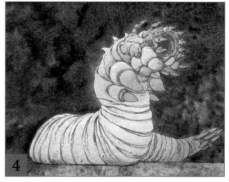

PAINTING THE BACKGROUND
Mix a large quantity of color in a bowl, using ultramarine blue, burnt umber, and purple. This mixture should be very dilute. Use only water. Cover the entire background working around the shape of the creature, leaving a band clear across the bottom of the image. Dilute the paint a little more, creating a slightly lighter shade, and paint the ground in the same way as before. If the color becomes too dark, use a tissue to take some off.

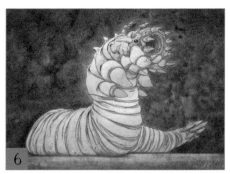

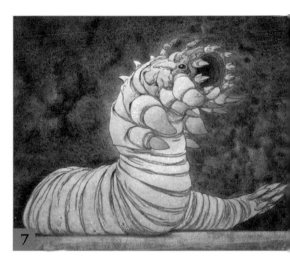

CREATING A GLOW

Once the background is dry, repeat the process, but leave an area close to the outline of the creature free of this additional layer. The effect will make the creature "glow."

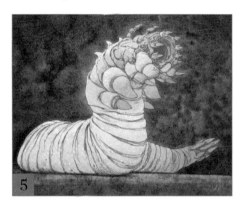

LIGHT AND SHADOW

Use a pale yellow pastel pencil across the ground, close to the body of the creature, with horizontal strokes. Blend this into the background with your finger. Using dark warm gray and black colored pencils, work into the line work of the creature. Lines should be darker in the shadows and lighter where you wish the line work to fade into the background color.

ADDING DETAIL

Add green ink to the extremities in precisely the same way as in step 3. Deepen the color of the mouth in the same way, using layers of purple ink and burnt sienna ink.

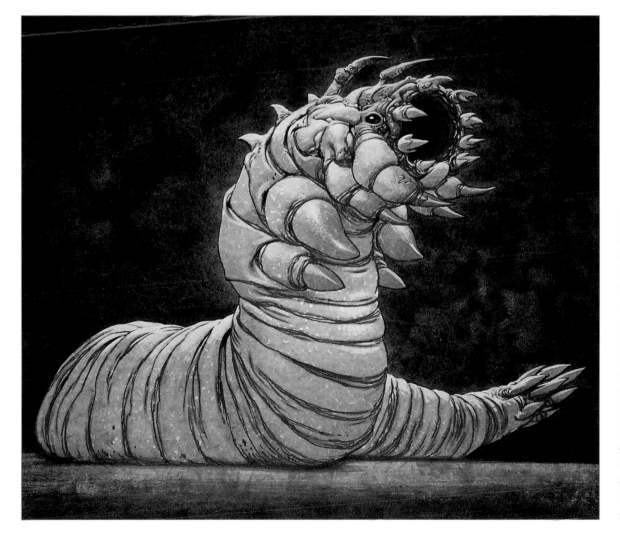

FINISHING DETAIL

Use opaque white acrylic (with a little yellow ochre) to paint along the upper surface of the creature, making sure to paint out the line work where it touches the background color. Also add highlights to the extremities and mouth parts using the same color.

CHARACTER SKETCHES: SWAMP ELEMENTAL

The swamp elemental is a powerful spirit that controls its environment and can meld together many natural elements to create a physical form. The creature is difficult to spot because it is made of the same vines and plants as its habitat. Other swamp-dwelling creatures, such as snakes, can get caught up in the swamp elemental's vines; indeed, some favor this habitat as a good source of cover.

The swamp creature usually emerges very slowly from the waters. Its movement is slow, but its powerful thrashing "arms" can be very dangerous. It can also change shape quickly and climb trees and other vertical surfaces by "growing" up them. An unwary traveler could be engulfed by the swamp creature and sucked down into the swamp and an untimely death.

COLORING THE BEAST
This fearsome creature was colored using Photoshop, with the greens and browns created with the airbrush tool. This allows you to spray on different layers of color to build up the variety of shades. Using a graphics tablet will help you achieve smooth lines as the vines curve around the body form; this is much more sensitive than a mouse for drawing.

CREATING THE HAND
Make up the rough skeleton of the hand from branches, and then draw vines and leaves around them to create a three-dimensional form.

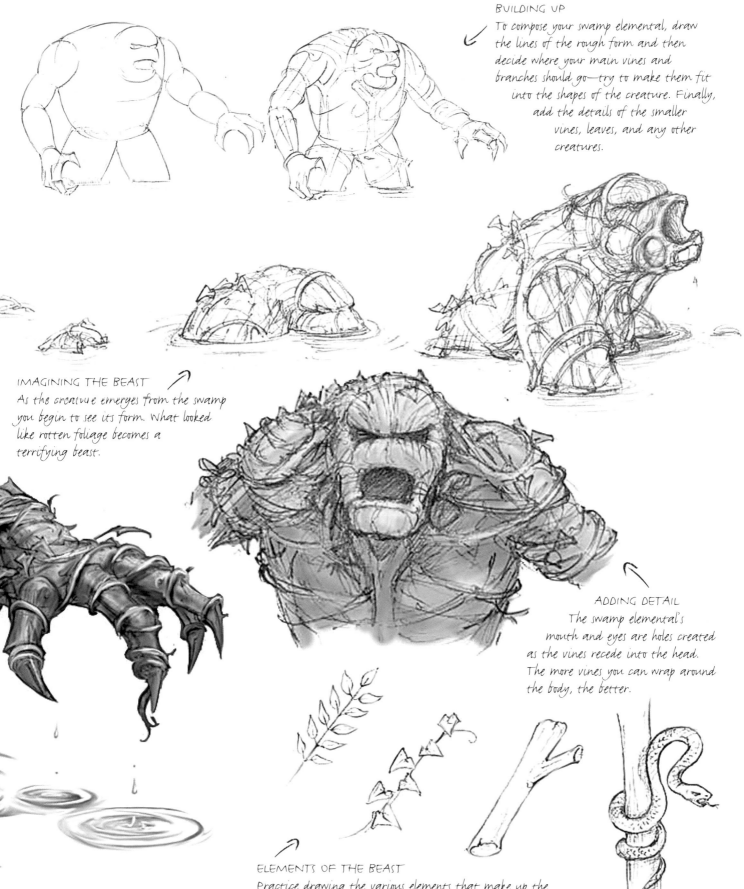

BUILDING UP
To compose your swamp elemental, draw the lines of the rough form and then decide where your main vines and branches should go—try to make them fit into the shapes of the creature. Finally, add the details of the smaller vines, leaves, and any other creatures.

IMAGINING THE BEAST
As the creature emerges from the swamp you begin to see its form. What looked like rotten foliage becomes a terrifying beast.

ADDING DETAIL
The swamp elemental's mouth and eyes are holes created as the vines recede into the head. The more vines you can wrap around the body, the better.

ELEMENTS OF THE BEAST
Practice drawing the various elements that make up the creature, such as branches with leaves, vines, logs, and snakes.

CHARACTER SKETCHES: SWAMP RAPTOR

Swamp environments present enormous opportunities for the fantasy artist. What may be found lurking in the pool of stagnant water? What mutated monstrosity might lie in wait behind the gnarled trunk of a swamp tree? Only the artist's imagination limits the possibilities when inventing incredible creatures to populate this hostile world.

Real creatures provide a great source of reference and can be combined, distorted, and exaggerated to create an endless array of fascinating and potentially lethal monsters with which to inhabit any fantasy scenario.

Crocodiles, dragonflies, snakes, and any of the other denizens of the swamp can be used as an ideal starting point, and exaggerating them can yield amazing results. Nothing more exotic than a humble toad, found almost everywhere, has been used as a basis for this swamp raptor.

EXPRESSION
This experimental sketch of the swamp raptor's head gives it a fierce expression, long tongue, and sharp teeth, all of which emphasize its predatory nature.

TECHNIQUE
During the early stages of the illustration the artist is free to explore ideas and to push the concept of his or her creation as far as possible. It's always good to work quickly at this stage, to play freely with the drawing, and to exploit happy accidents as you scribble; you may inadvertently discover something that takes your creation in an entirely new direction. These initial sketches were executed in broad-tipped marker pen.

CREATING FORM
Simple geometric forms are used to create a solid basis for the drawing. Experimentation with these shapes is always a good idea because the final look of the illustration can be improved dramatically by small alterations at this stage.

EMPHASIZING PHYSIQUE
This unrefined sketch explores the balance of masses within the creature's physique.

THE FINISHED DRAWING

Once a final form was arrived at, a light box was used to trace through a clean-line pencil drawing onto illustration board. This image was then enhanced by overdrawing with a very fine sable brush and India ink. The final result was a clean black-and-white rendering of the monster. This was then scanned into the computer and colored using Photoshop.

GEOMETRIC FORMS

Very simple geometric shapes can be used to create the fungus that adorns the monster's back. Once the basic forms are established, the artist can embellish these with texture and color.

GESTURAL DRAWING

The aim here is not to worry unduly about the detailed appearance of the monster, but rather to explore the way in which it might move and stand. It's always worth thinking about how your monster might look in action rather than focusing solely on a particular static pose.

CAMOUFLAGE

As the swamp raptor waits for its prey, the moss and toadstools growing on its back emphasize the raptor's natural camouflage.

CHARACTER SKETCHES: SWAMP DRAGON

The swamp dragon is essentially a giant eel, but it shares characteristics with its dragon relatives, so you can apply the basic principles for creating dragons (see page 40). This dragon feeds mainly on carrion but will attack and consume live prey in times of extreme hunger.

Throughout the summer months these dragons hibernate, preferring a cooler, damp climate.

Swamp dragons are currently seen as an environmental barometer: Because they have a low tolerance for human-made pollution, the presence of a swamp dragon in a location indicates a healthy ecosystem.

CREATING FORM
This construction sketch shows the coils of the body both above and below the water.

WATERCOLOR METHODS

Here are the three basic ways of applying watercolor.

WET-ON-WET
Clean water is applied to the paper first before applying color. The paint spreads out over the wet paper to create very subtle cloudy effects. This method can also be used with acrylic, and in this case several layers were added in the same way beause acrylic is waterproof once dry.

WET-ON-DRY (BLEED)
Colors are applied over others that have not yet dried, so they bleed into each other to create interesting color and tone changes while still retaining crisp edges.

WET-ON-DRY AND ERASING
Colors are left to dry before applying another color. The second application dries with hard edges, so this is the best method for sharp details. You can also create highlights or modify an area by lifting off some of the color—handy if you have used too dark a hue. Clean water is applied to an area and then taken off with blotting paper or a small sponge.

DEVELOPMENT SKETCH
This dragon's horns operate like the spines of a porcupine, folding down underwater, and perhaps only becoming erect as a warning to potential enemies.

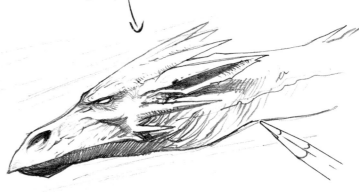

Sinister, cunning *Angry*

Tired, sad

EYES AND EXPRESSION
It is often said of people that the eyes are the windows of the soul, and as these examples demonstrate, eyes can be used to convey mood and character in fantasy creatures also. As with humans, the shape of the eyes and the way the brows distort around them can give a strong indication of what the creature is feeling.

Docile, passive

3-D VISION
For three-dimensional vision, the eyes have to be set on the front of the head, facing forward. Fish, with eyes on the sides of their heads, don't see in three dimensions, which is why a fish in a tank can't tell how far away the glass is until it hits it.

PAINTING THE CREATURE
The beast was painted in ultramarine blue, burnt umber, yellow ochre, and purple watercolor paints, with opaque white acrylic for sharp highlights. The line work was drawn in waterproof black India ink, with a fine brush. The fine point was achieved by rolling the brush tip against a sheet of scrap paper or blotting paper. The painting was created on a hot-pressed watercolor paper.

HABITAT
Rotten vegetation hanging from the beast illustrates its natural environment.

CHARACTER SKETCHES: KROPECHARON

The kropecharon is an insectlike creature, just under 3 feet (1 meter) tall. These arthropods are cunning, but despite their primitive look, they exist in civilized social units. Kropecharons live in tribes, in saltwater mangroves and estuaries, fishing and hunting for survival. They also keep other arthropods, such as crabs and beetles, as livestock, fashioning tools and weapons from their shells.

Ranging from microscopic insects to crustaceans, there are over 1 million known species of arthropods, providing plenty of inspiration for the imagination. Despite the wide variety of creatures in this family, the bodies of arthropods are remarkably similar. They have a hard body covering, a segmented body, and jointed legs, but no backbone. Inspiration for the kropecharon was drawn from several insects. It has features similar to wasps, cockroaches, crickets, and the praying mantis. Like most insects, kropecharons are segmented and angular, with a very pointed body shape.

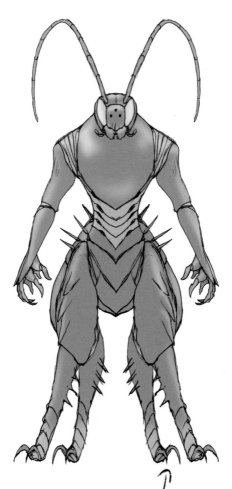

SIDE VIEW
Kropecharons stand upright despite using four legs for moving, providing them with good balance while leaving two arms free for using tools.

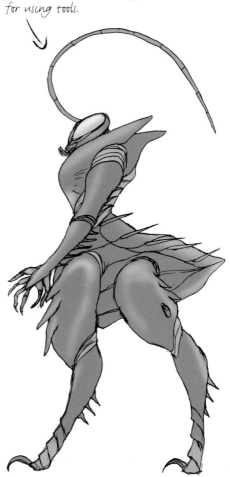

CREATING FORM
To create the kropecharon, begin with simple shapes.

EVOLUTION
Having evolved to stand upright, the kropecharon can see over the plants and debris that cover its mangrove swamps.

HAND
The kropecharon was really a six-legged creature, but the front two legs have evolved to function as hands, grasping objects and tools, with two opposable thumbs. →

SHIELD
Living among mangrove swamps, the kropecharons are able to harvest the bounty of the forests as well as the sea. They use the tough shells of large swamp crabs as shields for hunting even larger land beetles.

PAINTING IN SEGMENTS
Once you have the basic design for this creature, sketch and paint each segment of its body individually, using Photoshop, then assemble for the final image. This is an unusual way to create an image, but it works well for an arthropod.

FOREST BEASTS
GETTING INSPIRATION

A walk in your local wood or forest could provide natural inspiration for this environment, but for more tropical creatures try reading about the rain forests of Madagascar and the Amazon.

1 This brown bear looks cute and friendly, but don't be fooled. It is a dangerous woodland beast.

2 Many creatures protect themselves by looking like their environment. This one resembles a leaf, but your fantasy creature could look like a whole tree.

3 Don't forget to think about where your creature might live or how it looks after its young.

4 When observing nature, don't just look at the animals. The environment offers lots of interesting possibilities, too.

1

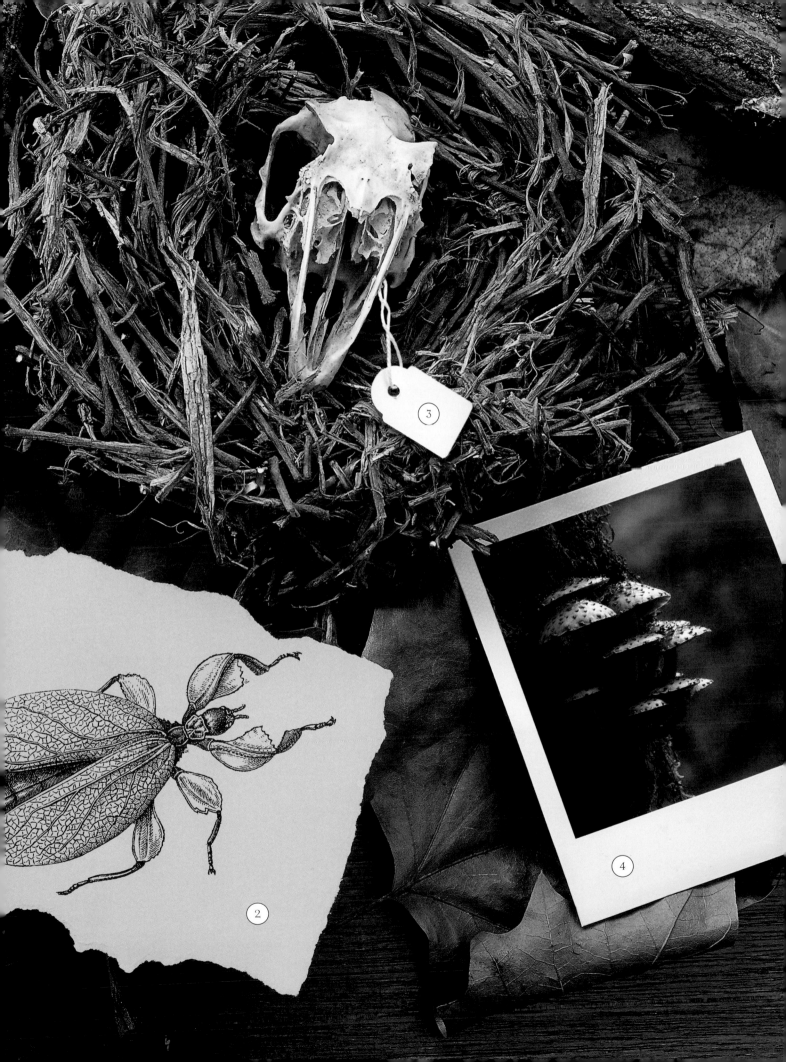

CHARACTER SKETCHES: TROLL

Trolls are misshapen and ugly, a fearsome humanoid race from Scandinavian folklore. Traditionally disliking light, they dwell in forests and dark places, and tend to come out only at night. They are voracious and omnivorous eating machines, spending almost all their waking hours searching for and consuming food. Their proportions and gait are similar to those of baboons and orangutans, but they stand much taller, at around 6 to 7 feet (1.8–2.1 meters). They are rarely, if ever, portrayed as friendly creatures.

The folklore status of trolls diminished with the advance of Christianity, and they were largely surpassed by more devil-like demons who seemed even more monstrous and destructive. However, that is not to say that they are not still feared by humans.

PHYSIOLOGY FACT FILE

Size:	Up to 7 feet (2.1 meters) tall
Weight:	658 pounds (298.5 kilos)
Skin:	Dark green-brown fur, turning to mottled gray with age
Eyes:	Pale blue-green
Signs:	Tendency to make nests under bridges; random piles of small stones, because droppings petrify on contact with the air

DRAWING THE HANDS

Trolls are not noted for their manual dexterity; any tools this creature might use would be primitive and not very effective. You can to some extent use a human hand as a guide to structure, but you might choose to give the hand fewer digits, as shown here.

1. Always start with the most prominent feature, the knuckles, which are positioned on a curve determined by the angle of the hand.

2 Add the main digits, placing the thumb slightly behind the first finger.

3. The outlines of the hand and fingers are determined by the thickness of the skin and muscle covering the bones. Avoid straight lines, and exaggerate the curves if desired to give the impression of fat fingers.

INSPIRATION

Often a seemingly unrelated object can help to inspire and dictate a character's shape, in this instance, a boulder. When trolls expire, their bodies contract into the fetal position and petrify, releasing the heavy calcium content of their skeletons and turning them to stone.

EXPLORING AN IDEA
Using the boulder shape as reference, hang limbs off the shape until you are happy with the design.

3. Arms too high, no space for the ears. Legs too straight; this troll would fall over.

2. Looks like a head only. Arm too low.

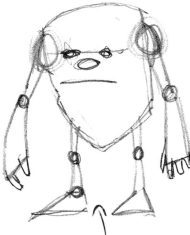

1. Looks too much like a Potato Head.

CHOOSING YOUR POSE
Once you have a shape you are happy with, work on the creature's pose.

4. Getting closer.

STRENGTHS
This troll looks as though it could produce great bursts of speed when on all fours.

SEE THE ARTIST AT WORK ▶

COMPARING SKETCHES

Experiment until you find the perfect ears for your creature.

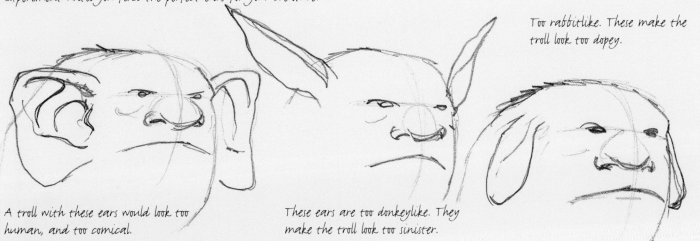

Too rabbitlike. These make the troll look too dopey.

A troll with these ears would look too human, and too comical.

These ears are too donkeylike. They make the troll look too sinister.

ARTIST AT WORK

The artist enlarged the preliminary sketch on a photocopier up to the final size for the painting, then copied it onto colored paper using a color copier, with the color settings adjusted to give the line work a greenish cast. Color was added using transparent acrylic washes and colored pencil, with opaque color used only on areas of highlight.

COLORS USED
ACRYLICS
VIRIDIAN GREEN
RED IRON OXIDE
YELLOW OCHRE
WHITE
ULTRAMARINE BLUE
COLORED PENCIL
PALE YELLOW
FRENCH GRAY DARK
FRENCH GRAY MEDIUM
FRENCH GRAY LIGHT

COLOR BEFORE PAINTING
Enlarge the pencil sketch on the computer, removing unnecessary lines. Then print the image in gray scale on plain paper. Photocopy the image onto colored paper (in this case gray) using a color copier, with the color settings on the copier adjusted to make the lines take on a greenish cast.

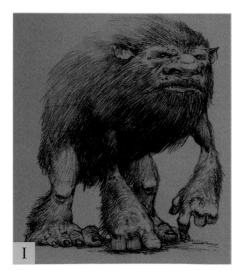

1

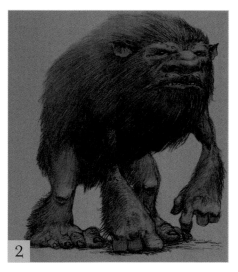

2

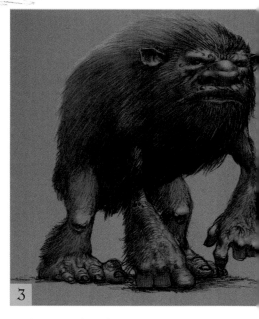

3

FILLING IN THE BODY SHAPE
After stretching the paper onto a board and allowing it to dry, apply a thin wash of acrylic to the figure only. The color is a muddy green, achieved by mixing viridian green with red iron oxide. After the first wash has dried, add extra layers to darken areas of shade.

SKIN VARIATIONS
Using a pale yellow colored pencil, color the lighter areas, paying attention to detailed areas such as the hands and face. The loose sketch lines are left visible, becoming wrinkles, hair, and creases in the skin.

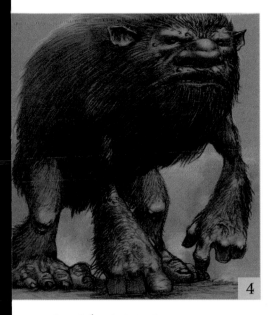

CREATING SPACE

Using medium and dark French gray colored pencils, add smoke or dust behind the figure. This breaks up the flat gray of the paper and brings the figure forward.

ADDING DEPTH TO THE SKIN

Begin building up the shades on the light areas with body color. Start by mixing a color to match the color the pale yellow colored pencil appears to be on the gray paper; then lighten it with white, yellow ochre, red iron oxide, and a touch of viridian green.

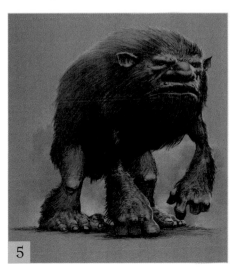

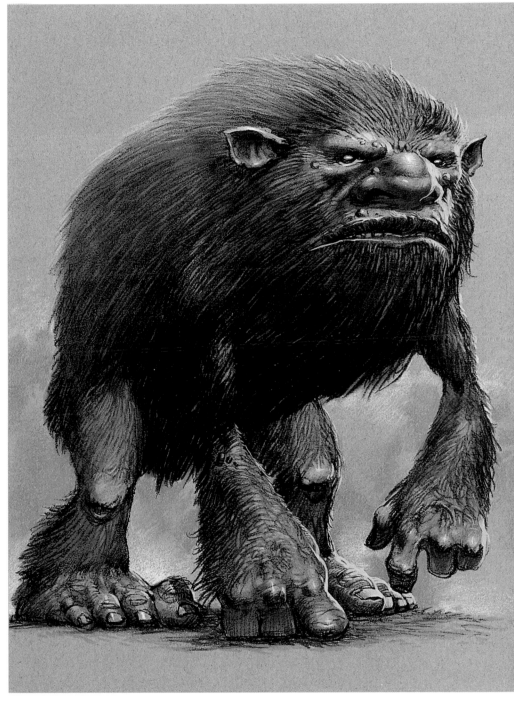

EXTRA LIGHTS

Build up to bright highlights; then add a second light source along one side of the face and hands to give the skin a reflective, shiny appearance. These colors are achieved by taking the previous flesh tones and adding more viridian green and ultramarine blue. Pick out the eye with a dot of light French gray colored pencil.

CHARACTER SKETCHES: RAZORBACK

The razorback is huge, up to 8 feet (2.4 meters) long and weighing 660 pounds (299.5 kilos). Ferociously territorial and constantly alert, this beast, if encountered, would be ready to defend its family group, and is likely to be found in a powerful stance ready to charge down any intruders.

For telltale signs of the razorback, look out for trampled undergrowth, worn paths through dense forest, and loud grunting and smashing sounds. When drawing the beast, try showing some blood around the tusks and mouth, for added effect, or even a snort of steam coming out of its nostrils.

TAIL DETAIL
The tail is as formidable a weapon as the tusks. It is short and strong with dangerous spikes that can cause massive injuries.

CREATING FORM
The shape of the razorback is made up largely of overlapping circles. Once these are in the correct position, it is just a case of adding in the details. Overlapping shapes give a sense of depth and will help bring your creation to life.

DEFINING FEATURES
The razorback has a boarlike body but takes its name from the three rows of spikes that run the length of its back. The outer spikes are large and flat, protecting the creature from attacks by larger or overhead creatures. The center row is smaller, and runs directly along the spine.

ADAPTING REALITY TO FANTASY
The razorback's hoof very much resembles a pig's foot, only bigger and with more hair. A pig's foot is primarily made up of two large modified toes.

SIDE VIEW
The configuration of the razorback's tusks allows it to lower its head when charging, which protects the delicate areas such as the throat and only exposes the sharp tusks and thick skull of the top of its head. At full charge these tusks are easily capable of penetrating armor and impaling any enemies.

CAPTURING THE HEAD
The head is broad and flat, with a thick skull that protects the razorback from injury when charging its victims. Small beady eyes peer out above massive tusks and teeth. The head of this beast is unusally symmetrical.

COLORING WITH LAYERS
This beast was hand drawn and finished digitally, using Photoshop, but it could be painted traditionally. Apply colors on multiple layers, starting with dark red and contrasting with a bone color. Work from dark to light to build up levels of shadow and highlights, and refine the detail as the work progresses.

CHARACTER SKETCHES: CENTAUR

Centaurs, a powerful cross between a horse and a human, are mythological creatures with a rather hazy history. Some say they are the offspring of Pegasus, the winged horse, while others believe they were born of Ixion, king of the Lapiths, as a punishment for his murderous and depraved ways. This would explain their savage and mischievous behavior.

Centaurs are renowned hunters and incredibly fleet of foot. They are nomadic, roaming vast areas of woodland between temporary campsites. These abandoned sites, replete with hoof marks, are usually the first indication of their secretive presence.

The variations in the markings of horses are paralleled in those of a centaur, but dappled varieties are very rare.

ACCESSORIES
Additional detail can make a creature more interesting and will tell the viewer something more about it. In the case of the centaur, the use of leather accessories combined with leaves and plant motifs help to reinforce the idea that the beast is attuned to nature and a creature of the woods.

VIEWPOINT
The angle from which a creature is drawn can alter how we perceive it. Looking down on the centaur can make it appear more vulnerable—perhaps the viewer is high in a tree, about to ambush the unwary creature. In contrast, a worm's-eye view can make the figure appear more powerful and imposing.

SKETCHING THE BEAST
At the sketch stage you can make changes very easily, and redrawing is an important part of the process. Work up a loose sketch of the whole piece to make sure the key elements are right, before tightening up the detail.

SENSE OF MOVEMENT

The examples, contrasting hair and accessories in a static pose with those in movement, highlight the way in which you can create greater drama and give the impression of the centaur galloping along.

COLORING THE BEAST

The centaur is painted in acrylics, working from dark to light. When the darkest areas are painted, apply a wash of diluted paint over the whole image before building up the highlights.

FORM

The centaur is a human and horse combined; and to put the two together successfully and create a realistic character, you must become familiar with both forms.

CHARACTER SKETCHES: FOREST DRAGON

These dragons are limbless and wingless, perfectly adapted to life in dense tropical or deciduous forests. Their closest relatives could perhaps be the large constrictor snakes, like the python and boa constrictor. The forest dragon needs to move and hunt in much the same manner.

This dragon has no pyrogastric glands, so it does not breathe fire. Being cold-blooded, it hibernates during the winter months.

PHYSIOLOGY FACT FILE

Size:	Up to 120 feet (36.5 meters) long
Weight:	4 tons
Skin:	Variegated green-brown
Eyes:	Viridian (self-illuminating)
Signs:	Deep furrowing trail on ground; trees scoured of bark from ground level up to the leaf line

DRAWING SCALES
Drawing scales isn't difficult, but it can be tedious. However, certain techniques make it easier. Often it is best to restrict the fine detail for the part of the beast you wish to use as the focal point, treating the rest in a more impressionistic manner. Only the larger scales need to be drawn, with the rest shown as short strokes or dashes.

HORNS
Horns can be mainly for display purposes—attracting a mate, warning off enemies, or giving the creature added status within a group. Look at dinosaurs for inspiration. They can be any color the artist chooses, and can even have patterns, so search out real examples for reference.

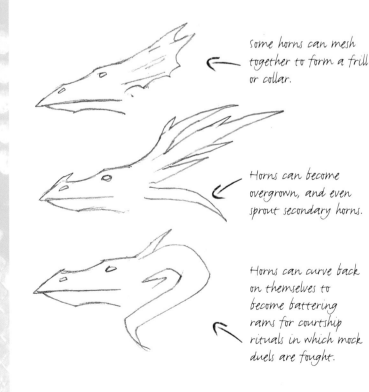

some horns can mesh together to form a frill or collar.

Horns can become overgrown, and even sprout secondary horns.

Horns can curve back on themselves to become battering rams for courtship rituals in which mock duels are fought.

HORN PHYSIOLOGY

A dragon's horns would probably grow from places where bone was close to the surface of the skin. The shaded areas in this sketch illustrate those places—nose and brow ridges, skull, and the heavy part of the jaw toward the back.

WHY HAVE HORNS?

The number of horns is unimportant—there can be as few or as many as you wish—but always bear in mind that horns have three purposes: attack, defense, and display.

WHY DO HORNS POINT BACKWARD?

Look at nature to find your answer. Animals with forward-pointing horns are fewer in number. What kind of animal would charge face first into an enemy, especially a similarly armored beast? It would risk injuring the very parts—eyes, nose, and head—that it seeks to protect. Most horned creatures use a "raking" action, swinging the horns in order to slash at prey or enemies. This movement causes greater damage with less effort.

SEE THE ARTIST AT WORK ▶

COMPARING SKETCHES

To begin with, your dragon pose can be as simple as a jagged line, with a triangle indicating where the head will be. The pose and structure can be built from this "core" line.

To create the look of an aggressive forest dragon, draw a coiled tube, which tapers toward the end of the tail. This can be as long and complicated you wish. Allow the lines to go through each other, as this helps to link up the coils—unwanted lines can be erased later.

This dragon looks like a cobra, aggressive and ready for action. This pose was abandoned in favor of a more relaxed one reminiscent of heavy snakes such as pythons and constrictors. These snakes are not known for their speed; they lie in wait and drop on unwary prey, and a heavy dragon would conserve its energy in the same way.

ARTIST AT WORK

The artist photocopied the preliminary sketch up to the final size for the painting, then erased unwanted lines using a white correction pen, intensifying solid black areas with a fine black marker. The image was then photocopied onto light watercolor paper on a color copier, with the color settings adjusted to give the lines a greenish cast. Color was added using transparent layers of acrylic washes and colored pencil, with opaque color used only in the final stages to neaten edges and add highlights.

COLORS USED
ACRYLICS
LEMON YELLOW
ULTRAMARINE BLUE
PURPLE
BURNT UMBER
WHITE

FIBER-TIP PEN
BLACK

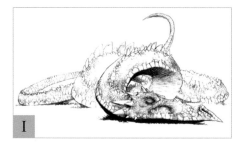

1

PREPARATION
Remove unnecessary lines from the drawing on the computer; then print out the image and photocopy it onto watercolor paper. The copy should be a color copy, with the colors adjusted to give the lines a green cast.

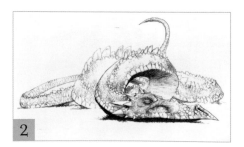

2

ADDING A BACKGROUND
Stretch the paper onto a board and allow it to dry. Then rewet the paper and add thin layers of lemon yellow acrylic quite loosely over the entire painting, making the yellow more intense over the dragon.

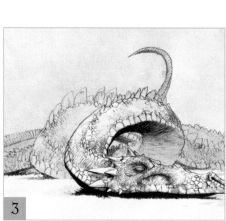

3

REFINING THE BACKGROUND
Allow the yellow to dry completely; then apply a second wash using an extremely diluted ultramarine blue with a large brush, but only as far as the ground level. Leave the area of grass the dragon is resting on untouched.

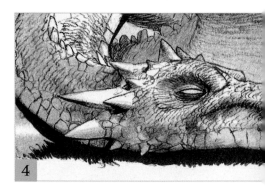

4

ADDING SHADOWS
Once this is dry, add more layers of ultramarine blue on the dragon only, leaving areas untouched to create the impression of dappled light on the body. Add details in the background, to disguise any mistakes on the previous step.

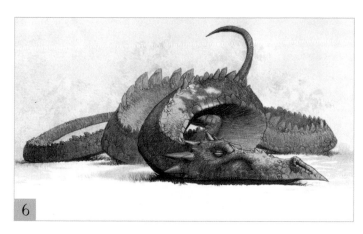

APPLYING A SKIN COLOR

Apply burnt umber washes over the dragon's body only. Use the strongest color on the head and nose, with the color diluted for parts that are farther away. This time the whole body is colored, including areas previously left untouched where the original lemon-yellow wash shows through.

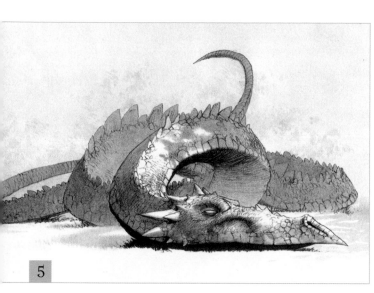

CREATING COLOR SHIFTS

Apply diluted purple washes over the blue on the dragon's body, leaving a few areas untouched. This defines the areas of light and shade. Dilute the purple further as the dragon recedes into the distance.

ADDING FORM AND DEPTH

Body color is added as highlights. Try to match the color beneath; then lighten, using white and lemon yellow in the foreground, with a touch of ultramarine blue for parts farther away. Most important, paint out the black lines on the upper, brightest edges. This lifts the shape of the dragon from the background.

CHARACTER SKETCHES: SABER-TOOTHED TREE CAT

With their enormous deadly sharp teeth, saber-toothed cats are well known as ferocious predators of prehistoric times. The saber-toothed cat does not hunt over long distances, preferring to lie in wait and then pounce, throwing itself at its prey, knocking it over, and using its teeth to deliver one fatal stab wound to a soft, fleshy area.

The teeth are basically those of large felines, but the same trait appears in several other mammals, such as weasels and bears, so there is plenty of available reference.

This animal is aggressive, so it is important to show it in action. Making it look as though it is about to pounce is a great way to convey its energy. All living things move, so a dynamic pose for your creature really helps create that illusion of reality.

FICTIONAL WORLD
Unwary travelers, beware!

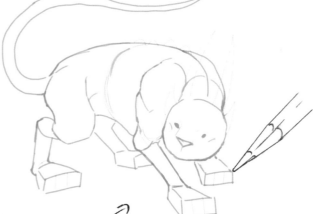

CREATING FORM
Begin by arranging simple but accurate shapes into a suitably ferocious pose. We rarely see things entirely in profile, and drawing them in this way can make the creature look static and lifeless, so practice drawing from more exciting angles.

HEAD DETAIL
The head and face of a creature are often the focal point of a drawing or painting, so the details need to be worked out quite carefully.

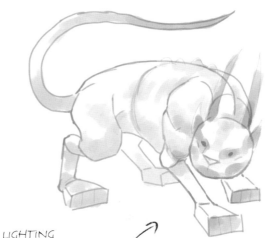

LIGHTING
Simple tone is applied to make the shapes appear more solid, as well as to explore ideas for lighting.

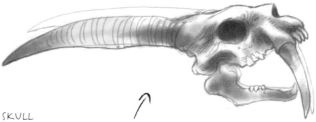

SKULL
Think about the structures beneath the skin, and what shapes they might take and why. The big teeth need big strong roots!

PAINTING THE CREATURE

This beast was created digitally with Corel Painter and a graphics tablet. Paint the beast on a sepia canvas, working from dark to light and gradually building up midtones and lighter highlights. Manipulating digital tools can achieve an exciting range of textures.

REAL-LIFE INSPIRATION

Making careful studies from real-life creatures can help give your beast realism and authenticity.

CLAWS

Like all felines, the saber-toothed cat climbs trees, and it has serrated claws to aid its climbing. This feature is echoed in the tail blades.

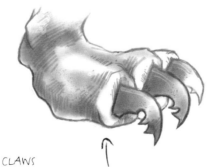

TAIL FEATURES

The tail is specially adapted to wrap around branches and dig into tree limbs to aid climbing. It also serves as a fearsome weapon—sharp blades grow out of the tailbones. Repeating a feature creates an attractive pattern, and varying the size adds visual interest.

CHARACTER SKETCHES: FOREST ELEMENTAL

The forest elemental is wise, quiet, and reflective. It is always rooted to the ground—whenever it takes a step, its feet quickly send tendrils into the earth. The elemental is able to change its size and shape and can grow new bark, foliage, and extra limbs when necessary.

As befits a creature of great longevity and thoughtfulness, the elemental's strides are quite deliberate, and one step may take hours, or even days. Grass and moss often grow up around the feet while it decides on its next move. Because of these long periods of inactivity, humans have been known to walk right past a forest elemental, thinking it a tree. But beware any inattentive lumberjack who might try to take an axe to this creature, for while slow to anger, this elemental is quick to strike once provoked.

INFLUENCE AND INSPIRATION
Study trees and forests so that you can create believable textures. If you sketch a few trees before creating your tree creature, you will find it's easier to produce realistic bark effects.

INTELLIGENT EYES
When creating a wise and thoughtful creature, make the eyes as humanlike as possible. This gives the viewer something to relate to, immediately understanding your intent to depict the character's personality.

MUSCULATURE
The limbs are humanlike, so pay attention to real human musculature, no matter how exaggerated. By using the lines of the tree bark to follow and accentuate the muscles, your creature will appear more realistic.

ELEMENTAL FEATURES
Details such as the long branchlike fingers, the patches of grass, and the roots on the feet can make all the difference when designing an interesting creature. Try to think of features that may surprise and entertain the viewer as well as be useful or logical for your creature.

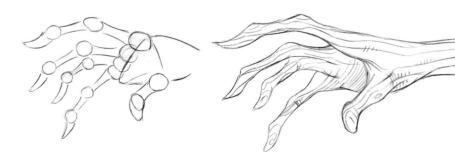

EXPRESS YOURSELF
You may need to sketch important features like the face several times before you are happy with the expression.

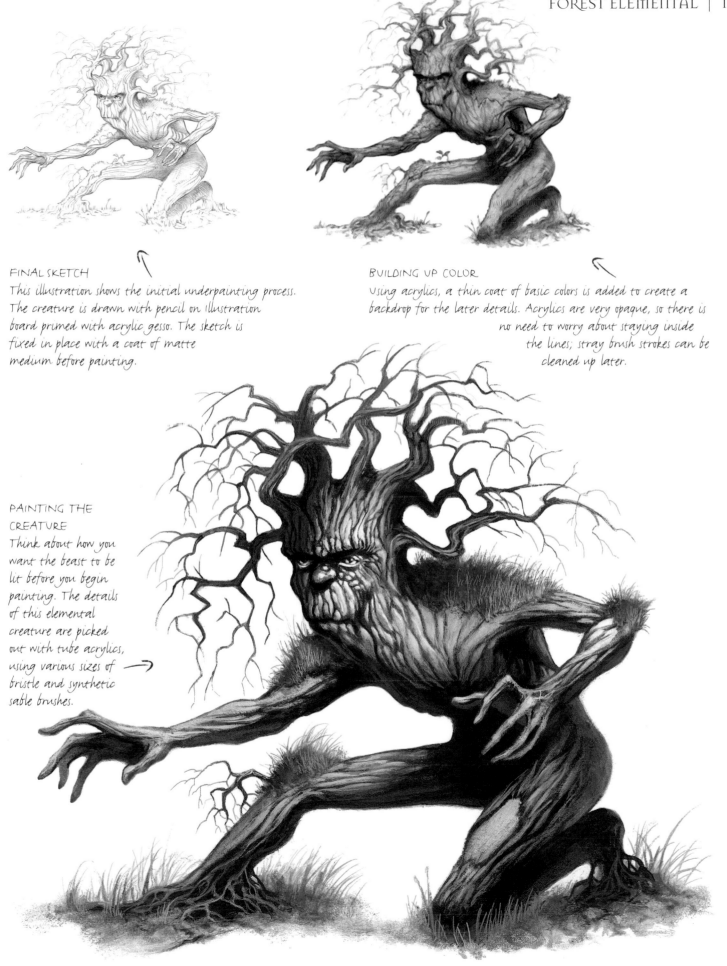

FINAL SKETCH
This illustration shows the initial underpainting process. The creature is drawn with pencil on illustration board primed with acrylic gesso. The sketch is fixed in place with a coat of matte medium before painting.

BUILDING UP COLOR
Using acrylics, a thin coat of basic colors is added to create a backdrop for the later details. Acrylics are very opaque, so there is no need to worry about staying inside the lines; stray brush strokes can be cleaned up later.

PAINTING THE CREATURE
Think about how you want the beast to be lit before you begin painting. The details of this elemental creature are picked out with tube acrylics, using various sizes of bristle and synthetic sable brushes.

Snow and Ice Beasts
Getting Inspiration

Who knows what may be lurking at the ends of the Earth, or at the top of a snowy mountain? Explorers' travel journals might give you ideas, but nature offers plenty of inspiration for your imagination.

1 Creating white creatures on a white background can be difficult. Look to nature for the textures and colors that can help you.

2 The Arctic fox has adapted to its home. It can curl up in the snow and keep warm by covering its face with a bushy tail.

3 Collecting fossils can be a free and fun pastime. You may not find dinosaurs, but plants and small animals can be found all over the place.

4 The walrus spends most of its life in the icy waters of the Arctic, but it can be seen on land, too. It has adapted very well to its dual environments. It walks on four legs, and air sacs in its throat enable its head to stay above water. A thick layer of fat keeps it well-insulated from the cold ice.

1

2

CHARACTER SKETCHES: ICE ELEMENTAL

The ice elemental, like the other elementals, is a creature with no physical form of its own, existing as energy and assuming physical form by the manipulation of its environment. It is composed mostly of ice and snow.

It is a slow-moving creature, relying on the rapid melting and refreezing of its physical form for movement. It can be easily outrun by a healthy victim, so it preys instead on the unwary and wounded creatures in its environment, lurking in crevasses and around glacial fissures.

Although composed of frozen material (ice water) and essentially a creature of bitter cold, the elemental is drawn to heat sources and drains the heat from its victims to prolong its own existence. It can thus often be found infesting both subglacial volcanoes and hot springs.

PHYSIOLOGY FACT FILE

Size:	Variable
Weight:	Variable
Skin:	Ice
Eyes:	None
Signs:	Frozen corpses

TRYING OUT IDEAS
The design of a creature that is so abstract is best achieved by an evolving design. Begin with a pencil outline, holding the pencil near the top to give a free, fluid line.

ALTERNATIVES
Make a series of sketches, trying to let your pencil have its head rather than thinking too hard about what you are doing. The artist Paul Klee called this method "taking a line for a walk." Work like this until you arrive at a shape you are happy with.

The hunched, crouched shape suggests wariness, something that creeps.

The large roaring head is designed to provoke fear in its victims and is more for effect than purpose.

DRAWING THE HEAD
Work into the pencil outline, adding and removing shapes as desired but avoiding overprecise definition.

FINAL SKETCH
The shapes reflect the materials the creature is made of—semifluid ice and snow. The teeth, horn, and talons resemble icicles, the curve of the back looks like a snow-covered hill, and the scaly pattern on the body suggests trodden snow. For useful reference, look at photographs of wind-sculpted snow and melting ice for the curves.

COLOR SCHEMES

A creature made of snow and ice is a mirror of its environment in the context of color, so it is important to consider the weather conditions and quality of the light. You can also use these to create mood. For example, the creature might look sparkling and almost cheerful on a bright day but much more gloomy and menacing in low light.

SNOW AT NIGHT
Snow always reflects the color of the sky, so at night its brightness will depend on the clearness of the sky and fullness and brilliance of the moon. Because night is generally colder than day, strong blues on snow can make it appear colder than simple grays.

AN OVERCAST OR DULL DAY
The snow mirrors the neutral grays of the sky, making it seem more emotionally vague or somber.

BRIGHT SUNLIGHT
Sunlight casts strong shadows. The side of the object facing the light source reflects the light source—the sun—while the shadow side picks up some of the sky color as well as taking on the hues of surrounding landscape features.

RENDERING ICE

Ice isn't completely transparent; air bubbles trapped within it make it translucent or cloudy. This has the effect of holding on to and amplifying colors within the environment. This sequence demonstrates the principle of creating the impression of hard ice—or any transparent or translucent material such as glass.

1 Use a spirit-based marker, which is waterproof when dry, in a pale color, and draw facet shapes, leaving gaps like a distorted checkerboard. The pale pencil outlines can be erased later.

2 Repeat the process, overlapping the facet shapes of the previous stage.

3 Repeat again, filling out completely any areas that fade into a larger structure or are overlapped by another part of the creature.

4 In the final stages, use a colored pencil to create darker shapes and pick out surface flaws, cracks, and so on. White acrylic or gouache is then brought in to pick out external shapes and highlights.

ARTIST AT WORK

The artist enlarged the preliminary sketch up to the final size for the painting, then traced the main ice shapes, without an outline, onto blue-tinted watercolor paper on a light box, using a pale blue-gray spirit-based marker. After stretching the paper, color was added using a blue colored pencil. Opaque white acrylic was applied for the snow and highlights on the ice.

COLORS USED
ACRYLIC
WHITE
COLORED PENCIL
BLUE
SPIRIT-BASED MARKER
BLUE-GRAY

FINISHING THE DRAWING
Work the drawing entirely in pencil, which is a suitable medium in this case because the creature is not especially colorful.

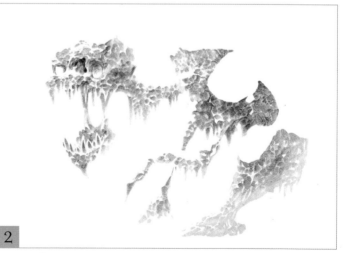

1
DRAWING BASIC SHAPES
Draw the basic ice shapes onto blue-tinted watercolor paper, with the enlarged sketch underneath on a light box for reference. The shade of the marker can be deepened by successive applications of the same color.

2
SHADING THE FACETS
Stretch the watercolor paper onto a board; then, when dry, use a blue colored pencil to shade the facets of ice created by the marker. Ice acts like a lens, inverting whatever image passes through it; so vary the shading, making some facets lighter at the top, some lighter at the bottom, some darker at the center, and so on.

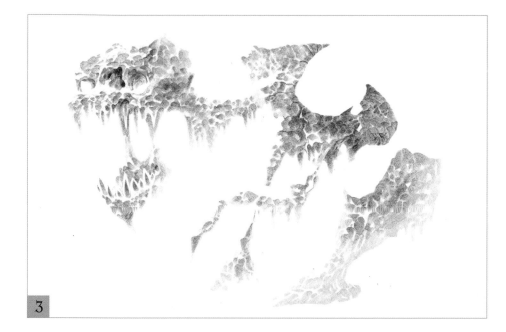

3

PAINTING THE FINAL SHAPE
Paint in the snow to create the final shape of the creature. Also add a few white highlights to prominent parts of the creature's shape.

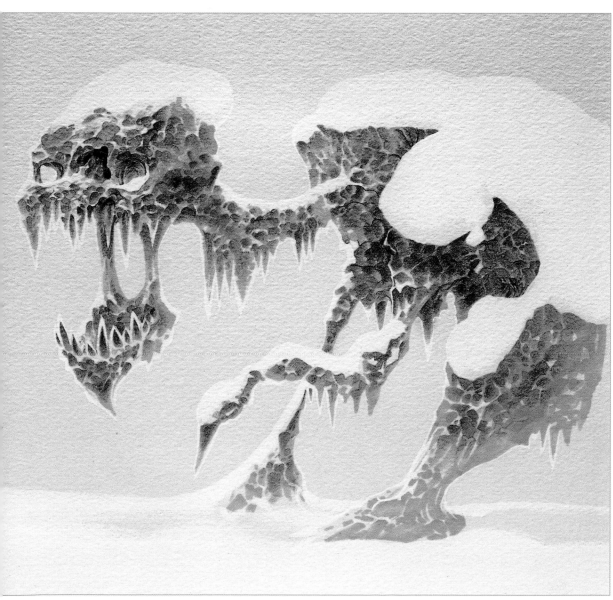

FINISHED PAINTING
This painting is minimalist; an example of how less really can be more. The flat background is eery and still, and the snow also has a muting quality. There is no wind or action to stir the environment. The painting conveys a beast that may be dormant for months, if not years.

CHARACTER SKETCHES: ICE DRAGON

Dragons have been part of our folklore for centuries. In fairy tales and legends they are celebrated and feared in equal measure for their astonishing appearance and destructive powers.

Numerous depictions of dragons appear in literature and art, and there are several in this book. You will notice certain characteristics common to most dragons: wings are commonplace, and they are usually big, but they can be any color. Most have scales but some have tough leathery skin; there are big-eared species and small-eared dragons, spiny-backed or smooth and straight, with soft bellies or with horny all-encompassing carapaces. And, not all dragons breathe fire; this one breathes ice.

DRAWING THE CLAW
The claw is made up of simple shapes and constructional lines.

PAINTING THE CLAW
Color the claw with pencil and add a wash.

COLORING THE BEAST
The ice dragon was created in Adobe Photoshop. After finishing the design, draw a loose sketch and make the final painting over it.

SIDE VIEW
Lizardlike protrusions make your beast look unearthly.

DRAGON'S HEAD, FRONT VIEW
The beast's head with sharp teeth and staring yellow eyes.

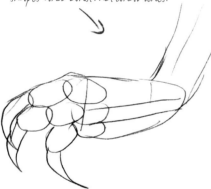

KILLER TAIL
It's all in the details, and this spiked tail makes a convincing deadly weapon.

CREATING FORM
Create the impression of bulk by keeping in mind the three-dimensional shape of the creature. Here simple shapes are used to sketch out the basic form.

ADDING DETAIL
Detail was added with a pencil and then a flat color wash was applied.

CREATING AN IMAGINARY WORLD
Reptile baby in a rocklike egg that won't crack beneath the weight of a broody female dragon.

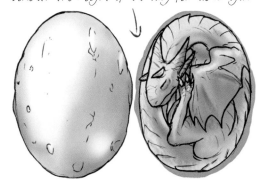

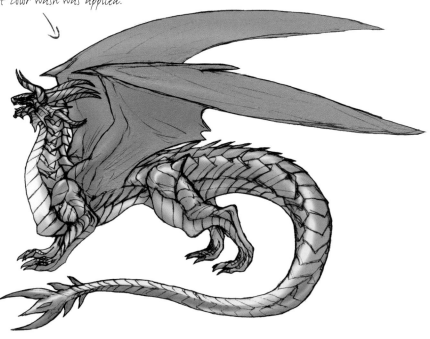

CHARACTER SKETCHES: YETI

The yeti, otherwise known as the Abominable Snowman, is a secretive, reclusive, nonaggressive creature inhabiting the mountainous regions of the Himalayas. The beast has been pursued and allegedly sighted by many mountain adventurers over the years. However, no one has managed to secure any real hard evidence for the creature, so perhaps these yeti sightings are better explained by the lack of oxygen at high altitudes, which can cause hallucinations.

Yeti enthusiasts claim that the creature walks upright on two legs, but views differ on its overall appearance. Reported sightings and footprints have suggested that it might be a species of bear or ape as yet undiscovered by humans. Making this yeti a hybrid, with similar characteristics to both bears and apes, covers all eventualities.

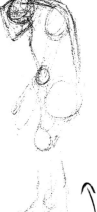

PAINTING FUR

There are many different methods for painting fur, and almost any drawing or painting media can be used, although opaque ones are perhaps the easiest to handle, and pastels allow you to achieve effects quickly.

OPAQUE PAINT
In this case acrylic paint can be good for painting thick, greasy fur, which clumps together.

COLORED PENCIL
This is good for coarse, stiff, longer fur, but it is harder to blend than pastel.

TRANSPARENT PAINT
Watercolor or diluted acrylic paint can be used for dense fur, but it can be difficult to paint pale fur. Use short strokes, feathering out the hairs of the brush to create a series of small parallel strokes.

PASTEL OR PASTEL PENCIL
This is good for short, soft fur. Rub with a finger or blending stick to soften the lines in places. Add a touch of pale yellow for white fur.

CREATING FORM
The primitive construction drawing shows the massive shoulder and hip joints where all the creature's main muscle groups are sited. A large, heavy body would be essential for wading through deep drifts of snow. The creature would also need to store an ample amount of fat for hibernation.

FULL FIGURE
This construction shows the animal influence, and the heavy shoulder and hip joints.

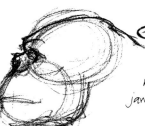

SIMIAN INFLUENCE
The skull of large apes is similar to the bear's at the top, but the head is much shorter, with a lower-set jaw and no snout.

URSINE INFLUENCE
Bears have flat, dense heads with big thick necks; the torso is usually heavy-set for storing fat during winter.

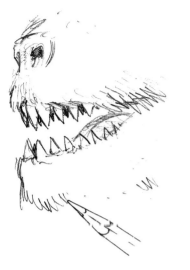

DRAWING TEETH
Sharp pointed teeth could make this character seem aggressive and carnivorous, but this yeti is a passive creature.

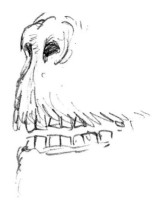

On the other hand, large flat-topped teeth might make the creature appear too comical, however. Strike a happy medium between the two extremes.

FACIAL PROPORTIONS
small eyes make the rest of the head appear larger.

PHYSIOLOGY
A believable creature is created by making the head half bear and half ape. The body of a polar bear reflects the yeti's environment.

COLORING THE BEAST
The white fur is short, thick, and greasy to keep out the cold. The yeti is colored with pastel pencil, so a smooth surface paper was used; otherwise, any grain or texture in the paper would show through on the fur. Colors used were white, pale yellow, and warm gray.

CREDITS

Quarto would like to thank and acknowledge the following for supplying illustrations and photographs reproduced in this book:

t = top; b = bottom; r = right; l = left; c= center

11t Courtesy of Fujifilm
26bl Courtesy of Seiko Epson Corp.
26bc Courtesy of Apple
26br Courtesy of Wacom Technology Co

All other illustrations and photographs are the copyright of Quarto Publishing plc. While every effort has been made to credit contributors, Quarto would like to apologize should there have been any omissions or errors—and would be pleased to make the appropriate correction for future editions of the book.

The following artists contributed to this book:

Simon Coleby—Sandwalker, Swamp Raptor
Jon Hodgson—Saber-toothed Tree Cat
Ralph Horsley—Night Elemental, Centaur
Patrick McEvoy—Sea Elemental, Desert Elemental, Forest Elemental
Lee Smith—Giant Viperfish, Razorback
Anne Stokes—Working Digitally, Sphinx, Swamp Elemental
Ruben de Vela—Kraken, Kropecharon, Ice Dragon

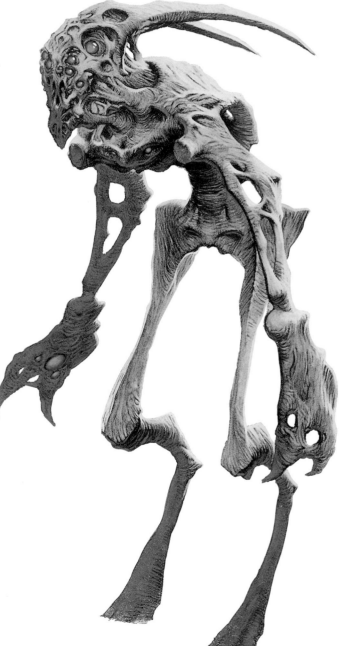